Meaningful Coincidence

Synchronistic Stories of the Soul

Volume 1: Wanderlust

Written by Alanna Zabel

AZIAM
BOOKS

Santa Monica, California

Printed in the United States of America
First published in 2017

ISBN: 978-0-9862075-1-8

TABLE OF CONTENTS

Introduction

"Synchronicity is the coming together of inner and outer events in a way that cannot be explained by cause and effect and that is meaningful to the observer." — *Carl Jung*

Do you remember a time when your life flowed with profound, effortless synchronicity? Oftentimes we are programmed to fit into our modern-day world, before we are even aware of our organic spirit, leaving our truer nature suppressed as a result. In this case we begin to identify with a superficial self, dictated by manmade rules. Personally, I believe that synchronicity is a huge indicator of "God" and universal perfection, reaffirming these moments as organic vs. manmade.

My intention is to connect you, the reader, to the organic, divine desires in your soul. You've probably read or heard general step-by-step programs of how to be "someone else," but imagine for a moment, if we stopped to pay attention to the universal reality specifically broadcasting through each of us. We would witness inexplicable awe at

the exquisite tapestry of artful magnificence trying to reveal itself in every moment. Sometimes we do not realize the sacrifices we make by ignorantly rejecting such magnificence, often for very menial worldly things.

Synchronicity is a concept, first introduced by the analytical psychologist Carl Jung, defining events as "meaningful coincidences" if they occur with no causal relationship yet seem to be meaningfully related. This book, *Meaningful Coincidence* is a three-volume spiritual memoir broken down into three major phases of my adult life. *Volume 1: Wanderlust Gypsy Princess* was a period of divine, instant manifestation of pure spirit, laced with mind-expanding synchronicity during spontaneous travels around the world, inspired by an inner voice, feeling, and intuition. These experiences lacked preparation or planning that would have otherwise dictated a specific, desired result.

I refer to this state of being as *The Dharma Zone*, which is defined in detail in my book, *As I Am: Where Spirituality Meets Reality*. This is the present-moment space where we are effortlessly connected to our truth, synchronicity is mirrored back to us, and our connection to God / Self is revealed. I coined this term as a means to define these miraculous, spontaneous experiences.

Naturally, as is common of the Self-realization process, the next phase of my life eclipsed into the shadow aspect. As I grew more aware of my Self with intense yoga practices, my shadow and ego began to mirror dark and heavy struggles, mostly with highly egoistic men. This served to mirror both my unconscious and subconscious, progressively liberate any inner ignorance from having participated in those dysfunctional attractions, while perfectly timed to resonate with

dharmic archetype and reveal my unique path. It's all a dream within a dream with infinite self-reflections anyway, isn't it?

Meaningful Coincidence Volume 2: Casting Shadows shares significant stories in my early thirties, when I worked for a world-renowned "guru," and dated a deeply manipulative sociopath. What began as a fairy tale of Prince Charming turned into a disconnected inner struggle while helplessly observing myself becoming emotionally attached to someone I wasn't even attracted to, and brain-washed to act in ways that were not true to who I was.

The darkness that followed separated me from *The Dharma Zone* for the first time in my life. I now had to discover the tools to access this naturally divine state that I had taken for granted, and now missed dearly. This led me into the last phase, illustrated in *Meaningful Coincidence Volume 3: Becoming Goddess*, a five-year period of self-healing, rebuilding trust, joy, and love, coupled with a confidently fierce authenticity, deep self-acceptance, and conscious boundaries. Personally, the greatest joy was the realization that nothing was actually lost – that miracles do occur and will re-establish one's dharma, regardless of time, age, or trauma.

Meaningful Coincidence poetically illustrates how to trust your personal and unique journey, to understand that we all have a unique role in this grand production of existence. Your life is full of unique-to-you miracles, unparalleled by anything manmade or contrived. They are simply waiting to be recognized and revealed. This book is a multi-layered expression of divine manifestation and beautifully orchestrated synchronicity, archetypal symbolism, spiritual death, and the unexpected re-birth that slowly and naturally followed.

I believe in the power of symbolism and archetype. As I relate to or experience synchronistic moments associated with deities, gods, or goddesses, for example, I do not believe that I am personally associating with that (or any) deity, but merely what they represent to me. At the same time, I believe a greater divine story is unfolding regardless of our individual interpretations, or attempts there at. I believe that our world is a complex holographic illusion broadcasting from "God," and that our fears, manmade desires, and attachments diminish the power of this expression, which is the very reason that we are alive.

There is nothing fictitious in my stories (aside from several name changes to protect identities of those involved in them), and it has taken many, many years to process why they have happened to me. Actually, I am still working on this, and probably always will. I feel deeply blessed on one hand, and perpetually anxious on the other. By sharing my experiences, I hope to entertain, enlighten, educate, and encourage you to choose your natural dharma over seductive, empty offers that policy makers, advertisers and sales teams lay in front of you, encouraging you to be someone else; someone who will benefit them.

I believe that our natural world is spinning out of balance for many reasons, one of which is the monkey-minded nature of people's attention on celebrity culture; wanting to look the same, dress the same, speak the same, etc. This denies one's unique dharma, which becomes rejected and unheard. Our collective subconscious broadcastings are becoming more difficult to hear truthfully with the over polluted manmade noise, destruction, and increasingly faster pace of life going on around us.

As I explain in *Part 1: Gypsy Princess*, a term granted to me by

my mother Joanne, who descends from Italian royalty and expressed overt dismay at my wanderlust ways that she perceived as a bohemian "gypsy," I was blessed to have only known an unbelievably synchronistic and spiritual life unbroken. I laughed in my sleep. I loved every morsel of life, regardless if it was "good" or "bad." I honestly did not understand depression. I truly wondered why people *couldn't just move through it,* when they expressed their mental and emotional struggles.

The reality is, I didn't have to work for it. It was a natural gift, and this is always dangerous if one does not necessarily "earn" a higher state of being consciously. Enduring a living spiritual death walked me through what it feels like to feel emotionally disheartened; void of the fluid, effortless magic that had always graced me before.

I'm not the type of person to push myself through my experiences and feelings, or re-route my focus around them. Instead I seek to dissolve each traumatic memory slowly with stillness, awareness, and realistic acceptance. I believe this to be the essential element in applying life experiences to our personal evolution as conscious beings. During this time-dependent process I continued becoming an even greater teacher than I ever knew I could be. This is a process that cannot be rushed or forced.

Growing up, I was a very shy child. At the same time, however, I was exceptionally talented. This meant that I was quite often the one chosen for solo's, speaking parts, lead roles, and so forth at school and church events. This duality has perpetuated throughout my life. I consider myself the "accidental" everything (designer, yogi, business owner, etc.). I have never been one to plan or calculate my future. Yet, I

have been blessed with experiences that surpass most business plans and brand objectives. This often creates more anxiety, as it lacks controlled results. However, I live for these experiences because they breed effervescent trust. This is my philosophy and teaching: I trust and surrender to the organic expression of universal and dharmic truth while being mindful and cautious of worldly traps and untruths.

I was raised in a very faithful Catholic family. We belonged to St. Bernadette's Church in Orchard Park, NY. My mother has always expressed a devout reverence for the Virgin Mary, and I grew up with a strong affinity to the Virgin. I also went to Catholic School at St. Bernadette's during this time. One morning, when I was about eight years old, we had a special mass during school hours. Our parents and families joined us for the mass, but I cannot remember the exact reason for the occasion. What I do remember is as vivid as if it had just happened yesterday. I remember the priest calling all girls who were present in the church with the name "Mary" to come up to the altar.

Now, remember, I was so shy that I would not have gone to the altar if he asked for anyone named "Alanna" to step forward. Yet, I wasn't functioning from normal reasoning at that moment, and this was the first time I recall this trance-like state, which I call *angel hacking*, where it felt as though someone else was acting for me. At that moment, I felt an incredibly strong knowing that my name was Mary, and an energetic push to go to the altar. So, I did. I watched my family looking dumbfounded at me with wonder. I heard my classmates whispering and laughing, but none of it phased me. The priest also knew my name wasn't Mary, and thankfully he did not embarrass me, or ask me to leave. I stood on the altar and received his blessing with the name of

Mary. When the hacking dissipated and I realized what had happened I felt embarrassed. I heard all about it when I returned to school as my classmates teased me relentlessly. I didn't understand it then, but as these moments of angel hacking have perpetuated in my life at divinely synchronistic moments, I have learned to both trust and relish them.

My mother has a spirituality that pervades all that she does. Her maiden name is Emmanuele, meaning, "God is with us," and she definitely lives up to her name. In regards to my exceptional natural talents, she reacted to teach me humility instead of confidence. My mother often reminded me, "Don't you brag; don't you boast; don't you ever think you are better than anyone else," when other people recognized my talents or praised me. This is not to say that my mother did not acknowledge my gifts and praise me and them, but she simply instilled a quality of humility that has stayed with me ever since.

In my late twenties, I wondered if this inner voice of humility quite possibly diminished opportunities that I could have greatly capitalized on. I pondered whether I had a self-sabotaging nature after repeatedly avoiding the limelight and/or worldly victories. With time and deep self-realizations, however, I realized that I was simply different than our Jones vs. Jones world, and grew very grateful of this characteristic instead. This brewed a life of living versus a life of winning, and I am grateful for that. For example, when I was a teenager playing in a state level finals tennis match, I watched the father of my opponent (who I had defeated countless times in other matches) white-knuckle coach her on the side. I saw the fear and pressure in her eyes, and I simply wanted her to win over me. So, I purposefully hit the ball into the net and outside the lines, throwing the match without her

knowing that was what I did.

On the surface, many people believe that I am ambitious, which I always find humorous. I understand why - I own a corporation, design my brand's clothing line, and founded a yoga studio. I manufacture toy products, I author books, I organize retreats and produce events. Yet, almost every project or brand offering that I have created has been a divine "accident." I listen from within, I observe synchronicity, I plan little, and I have always felt more comfortable acquiescing to life than seizing it; even during the time when I nearly died at the hands of my ex-boyfriend. I often wonder: is it easier to physically die at the hands of an abuser, or spiritually die while your blood continues pulsing through a body emotionally stagnant with traumatic memories replaying through its mind?

I do believe that current world affairs have reached a positive tipping point: the revelation of Goddess energy is upon us. This is not simply the superficial image of a pro-woman tribe, or faux feminism, over-sexualized and objectified images, but of a woman aligned with pure divine truth transcending shadow and death to emerge with a deep knowing and power to humbly serve, teach, and lead the world back towards natural balance.

I feel that there is a worldwide greater comprehension for reality-based spirituality – I see less attachment to illusions, religions, and fairy-tales. We're waking up. We're resisting conformity. We're demanding truth. People are seeking authentic voices to lead them deeper into their own truth. They're seeing through the facades of narcissistic "gurus" and growing confident in their own unique path. I am eager to share my stories of meaningful coincidence with you. I

hope very much that they inspire you to see your life with synchronistic wonder, dharmic reality, and to take a leap of faith into your next free-spirited adventure.

I have waited thirteen years to share these stories, because honestly, I was embarrassed to sound as though I believed myself to be *special*. It is only due to the fact that extraordinary synchronistic occurrences keep happening in my life that I feel a responsibility to share them. I also now believe that my stories have the ability to guide other people to seek their true natures. This inspires me as a teacher. The layers of synchronicity and profundity in my stories are unmatched to anything I have ever read, heard, or seen elsewhere. I hope they resonate with you and you will be able to share and witness similar stories in your own life after reading this book.

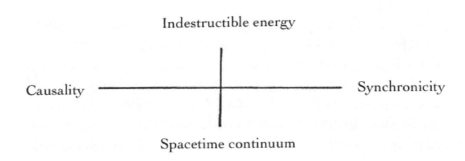

Diagram illustrating Carl Jung's concept of Synchronicity

Part 1

Gypsy Princess

This Gypsy heart of mine
Needs to wander free
To discover mountains and caves
Guarding the world's mysteries.

I will walk the unpaved path
I will dive into the darkest seas
Because that is where I will discover
The secrets waiting only for me.

Chapter 1

"The wound is the place where light enters you." – Rumi

Discovering Yoga | AZIAM

In my early twenties, I studied to be an actress. I studied in my hometown of Buffalo, NY, in New York City, and Oxford, England before moving to NYC to pursue my career. While living in NYC, I was working off-off Broadway. I retained a bi-coastal agent (NY – LA) and was working consistently doing commercials, industrials, and music videos (in addition to my stage work). I absolutely loved the art of expressing a story as truthfully as possible.

One morning my acting teacher decided to give me an abnormal character assignment, half as a challenge for growth, and half purely to ruffle my feathers, because that's just the kind of person that he was.

After rehearsing my new assignment for several weeks, the strong contrast of character (from who I was) clearly manifested as scenarios in my life that I noticed very quickly. My life began detouring in a new direction that felt negatively foreign to me.

James (my teacher) gave me the role of a girl who had a major breakup with her boyfriend, moved to Los Angeles, and her life fell apart. I, Alanna, was not dating anyone. I, Alanna, had no desire to live in L.A. (I disdained L.A., actually, as I was a "real" New Yorker). I, Alanna, was completely happy with my life in New York. Yet, within three weeks of intense rehearsals, I watched all of those facts change.

As I dove into my role, I was becoming my character. I met with my acting partner twice a week to rehearse. Shortly after practicing this new "character," I met a charming, independently wealthy fellow who was getting ready to move to Los Angeles. He developed a serious and persistent crush on me. He asked me to fly to Las Vegas, get married and take a helicopter to Los Angeles, where we would find a home to live. I knew that his proposition was too fast for me, and that I did not want to marry him, but I found myself strangely seriously considering it. He was not taking "no" for an answer. My conflicting opinions of Los Angeles contributed to the difficulty in conceiving this new possibility, but regardless of my concerns, I took the jump.

Was it a coincidence that one week after the idea of moving to L.A. crept into my consciousness that my bi-coastal agent landed me an audition in L.A.? At the time, it seemed to me that Destiny was pulling me to L.A. Or was it the repetitive practice of my newfound character's experience of *being* the "girl who moves to L.A." that was manifesting the means to fulfill the accumulated mental input, AKA rehearsals? Or

are they one and the same? Needless to say, I moved to L.A. on a whim and a prayer, had a breakup and my life fell apart. I was in a new city, and a superficial city at that. I did not like it much, but I had metaphorically checked in to *Hotel California.*

After a few auditions in L.A., I was eager to retire as an actor. In contrast to my classical training, the audition waiting rooms were filled with actors who lacked training and were obsessively focused primarily on how they looked. I hadn't studied to be a model who speaks on camera, I had studied to be an actor who dives into the character of another being and becomes that person with the intent to share a meaningful story.

I was feeling very anxious in L.A. Being a highly intuitive person, my energy system was overloading trying to decipher what people were really saying. In NYC, people are much more straightforward, which saves a lot of mental capacity in day-to-day dealings. Not in L.A., a city that's all about who you know. People air kiss and empty promise with the hope of "getting somewhere." I experienced a lot of lip service, with little follow through or reality based truth. I didn't vibe with the excessively sugar-coated passive aggressive and avoidant encounters I had, or the duplicitous friendships.

While I was learning my way around the city, I was also working as a waitress at a local restaurant. The owner of the restaurant took a liking to me. My vim and vigor personality, hard-working and sharp performance, and the fact that I was young, fit, and beautiful. He brought me to his personal catering jobs to serve parties for the rich and famous. I was meeting A list celebrities every week, and even though it was a lot of fun, it was also very eye-opening to see for the first time the

reality of these people off-camera. I wish that everyone in the world could see that celebrity-ism is make-believe. What the public sees is manufactured by the managers, agents, stylists, publicists, and assistants. Even more, actually, I wish that celebrity culture did not exist. It makes people who do not know the behind the scenes reality believe that they are less beautiful, less talented, less awesome, etc., and that simply is not true.

As I was closing up my lunch shift one afternoon, I was waiting to pick up one last ketchup bottle from a table whose lunch was taking longer than usual. All of my other clean-up duties had been completed. When the couple finally finished their lunch, I swept into get the ketchup bottle, and turned around to return it to the kitchen. During the time that I left, someone went through the kitchen with a sopping wet mop to clean the floors. That same someone forgot to put the mats back down, or even a sign that read "Caution: Wet floor."

My left foot hit the wet floor and slipped back underneath me. I was holding the ketchup bottle in my left hand, and in that fraction of a second when my left leg flew behind me, I landed on my left hand, breaking the glass and driving a huge thick chunk of the glass through the center of my hand. I often refer to this moment as my personal stigmata, ketchup included.

The accident devastated me. I was no longer perfect, for one, and secondly, this was the first time in my life that I wasn't "girl on fire," laughing in my sleep, get-up-and-go carpe diem right now. I was 23 years old, 3000 miles from home, alone with fake friends and flooded with sadness.

This accident ultimately led me to the realization that I no longer wanted to play anyone other than me, and the dangers of playing someone else. I was convinced that I ended up in L.A. as a result of my acting class assignment back in Soho, and I was finished playing other characters. I no longer wanted to be directed by other people according to what they wanted me to do. I wanted to understand who I was and to do the best job playing *me*. While I recovered, I found a little bit of time to dive in and discover who Alanna was, and what was her purpose in life.

I lived four blocks from a Starbucks in Santa Monica. Above the Starbucks was a yoga studio called Yoga Works. Although I had been teaching dance and fitness since I was seventeen years old, I had only tried yoga once before while living in NYC, when my managers at Equinox suggested that I would be an incredible yoga teacher. I had laughed at the idea back then.

Every morning, like clockwork, I walked to this Starbucks and ordered a venti-sized green tea before going for my morning walk. During this particular time, there was a young toddler who was in the Starbucks with her mother every morning, also at the same time I was there. I have always had a love for children, and children have always felt very comfortable with me as well. Each morning I would play with this young girl while we waited in line. Her mother told me that her name was Tasha.

After several weeks of our daily encounters, Tasha's mother approached me. She said, "Listen, my daughter is incredibly colicky, which is why I am so surprised with how much she enjoys you. She cries when we have to leave Starbucks each morning when you're here.

I am leading a Yoga Teacher's Training course upstairs at Yoga Works for the next six weeks. Would you be interested in trading yoga classes for child care?" I was looking for some quiet, contemplative time to figure out who I was. This seemed perfect. I accepted. Tasha's mother was from Australia and is a niece of the famous singer and actress, Olivia Newton John.

The first yoga class that I decided to take as part of my trade was a led Ashtanga class, taught by Maty Ezraty. When I signed into take class, the girl checking me in asked, "Have you done this before?" I answered that I had only taken one yoga class before, and she responded that this class was likely too difficult for me. I told her that I was willing to try. If you have any idea of what a First Series Ashtanga class looks like, you might have a good chuckle imagining how I was flailing around the yoga mat to keep up with each position. I recall how heavenly the final rest was after such a physical experience.

After class, Maty approached me. Very to the point, she said, "You're very good, but you must come every day." *OK*, I thought, *I will*. Aside from embarking on a yoga practice, immersing myself into the classes and community, I was hired by Yoga Works shortly after, working at the front desk and helping as a teacher liaison to Maty. The physical aspect of yoga came very naturally to me. Many of my teachers commented that I had "many lifetimes as a yogi," which I didn't take too seriously. Many people also asked me when I would begin teaching. I answered everyone the same, "For once, I am not going to teach this. Yoga is my personal vehicle to heal and discover, and I have no interest in teaching."

That is until one day while attending a class of a very popular instructor in Santa Monica. She said something that was anatomically incorrect. Given my fitness background, I was disappointed and felt less enamored by her. No longer able to find a class that challenged me, or an instructor who I sought to learn from, I knew that it was time to teach. I mentioned this to a friend of mine that same night. The very next evening I received an emergency call from Crunch Fitness (where I was teaching fitness). They needed a sub for a yoga class the next morning, and asked if could I do it. Without having had a yoga teacher's training under my belt, I said yes, and it was one of the most magical classes I have ever taught in my life. I didn't know where the words came from, how the flow was so fluid and organic, and I felt as though someone possessed my body and taught through me. It was another example of angel hacking.

After class, everyone complimented me, asking where I taught and how to take more classes from me. From there a well was tapped that has not stopped flowing since. Shortly after that experience, I created AZIAM, which stood for "Alanna Zabel, I AM," confirming my path to play me and only me, As I Am. My desire to express a character as truthfully as possible was now tasked with expressing my true self most authentically. I still had shadows and early life traumas to work out, though. The yoga process had officially begun.

Chapter 2

"Nature does not hurry, yet everything is accomplished." –Lao Tzu

Vipassana | The Process of Distilling

Now that I was teaching yoga, I thought it would be wise to actually take a Teacher's Training course. I was teaching classes at a studio in Brentwood called Maha Yoga, and several in-home private classes while continuing to practice Ashtanga Yoga every day. My favorite teacher, Tim Miller, lived in Encinitas, CA. I drove down to his studio from Los Angeles once a week to practice with him. It was a small, carpeted room three blocks from the beach and four blocks from Paramahansa Yogananda's ashram, The Self Realization Center. I would drive down the night before, sleep in my car next to the ocean, wake up to practice Ashtanga's first and second series with Tim, finish by

meditating in Yogananda's Meditation Gardens and drive back home to L.A.

When Tim announced that he was co-leading a Teacher Training in Los Angeles with an Iyengar instructor, Eddie Modestini, I was elated and quickly signed up for the course. Ironically and wonderfully convenient for me, the course was being held at the same studio that I was teaching in L.A., Maha Yoga.

On the first night of our training, a man in my class made an announcement to our group after Tim and Eddie had finished their introductions. His name was Scott Fallows. He shared that he lived in San Francisco and was originally intending to stay with a friend of his who lived in Santa Monica for each weekend of our training. Scott went on to say that his friend was pregnant with her first child and he felt by staying there he was intruding during such a special time in her life. He asked if anyone had an extra room or couch where he could stay each weekend for the next six weeks. I didn't hesitate to offer him the spare key off of my key ring to stay at my apartment and crash on my couch.

Scott was a very soft-spoken, mindful person. Looking back, I was still very obviously and embarrassingly working out my "stuff." I was functioning from less self-awareness than I do today, and I still struggled to fit in with Southern California's image based culture. This may very well be why Scott gave me one of the greatest gifts of my life, which was his way of thanking me for staying at my apartment during our training.

On Scott's last day staying with me, he told me that he wanted to give me a gift to say "thank you." The gift was a Vipassana course. I had never heard of this before and asked him to explain further. He said

that it was an ancient Buddhist meditation technique, and the typical courses were ten days in duration. He told me that there were meditation centers all over the world, but recommended one outside Fresno (North Fork). I asked him, "So, like a yoga retreat?" and he answered, "Well, not really, but kind of."

Awesome, I thought with bliss enhanced ignorance, *I love yoga retreats.* I happily and gratefully agreed to accept his gift, and together we went to my computer to register me for my "retreat." I selected a late August course, which was about two months later. I did not take any time to read further about the course in the least – in my mind, it was "like a yoga retreat," and that's all I needed to know. I also signed up for a carpool arrangement leaving Santa Monica.

Vipassana translates *As It Is*. To see things as they really are, in their true perspective, in their true nature. This practical technique of self-examination and scientific method of self-observation that, when practiced properly and consistently, results in the total purification of the mind and the highest happiness of full liberation. This is Vipassana, the very ancient meditation technique of India, rediscovered over 2,500 years ago by Gautama the Buddha, known as the Enlightened One.

The technique is hailed as helping a large number of people in India to come out of their suffering and attain a high level of growth in all spheres of human activity. Subsequently, the technique went to the neighboring countries of Burma, Sri Lanka, Thailand and many others. It had the same ennobling impact on the people of those countries as in India. The method traditionally involves ten days of total silence, spending roughly twelve hours a day monitoring your breath and bodily sensations. It is the purist path of meditation (void of mantra or

visualization of any kind) that I have ever experienced or practiced. I will always thank Scott Fallows for introducing me to this technique, and learning how *to sit*, which is the common reference to practicing Vipassana.

A couple months later, I received an email notification, reminding me of my upcoming Vipassana course, as well as connecting me with a man who lived in Venice, CA who could drive me to and from the center in North Fork. I contacted this man, Jon Ross, and we arranged our carpool.

One of the most profound results of Vipassana is an increased level of self-awareness. I really had no idea how "particular" I was in some regards (I will explain further), nor how attached I was to my health and fitness regime. Looking back, I really cannot help but chuckle to myself. Jon arrived in a Jeep SUV. I had packed to take with me: two full suitcases (which included a towel for each day of my trip – I preferred fresh towels for every shower), a yoga mat, five books, my journal, countless supplements, beauty products, and more. Jon looked a little shocked at what I had with me, even though he was very polite while opening his trunk to help me load my "retreat" gear into the back. When he lifted the trunk, I saw only a small duffle in the corner, which was clearly his only bag for the 10-day sit.

"That's all you're bringing?" I asked. "Well, yes," he answered me, "you sure seem to be bringing a lot." We continued our conversation while driving. It wasn't until we had just merged onto the 5 freeway that the reality of what I was embarking on began to settle in. I was in complete shock. Jon enlightened me that we were not allowed to read, take supplements, or do exercise, and that we would be in

silence for the entire ten days. By this time, I felt that it would be rude to ask him to turn around and take me back home, plus I thought, "How hard can that be? Just do it."

We do not realize how hungry, aggressive, and dependent that we are, until we are forced to sit, abstain, and witness ourselves truthfully. At least this is true in my case, and I now look out at the majorities in our society and recognize similarities of how I had behaved before sitting Vipassana. Heavens, I could have continued down a very ugly and selfish path. I also, funny enough, did not realize that I laughed in my sleep every night – "howled," actually is the term used by many fellow meditators with whom I have shared a cabin with over the years. Apparently, I "shake the cabin laughing in my sleep." That is one aspect of my personality that I do miss. I laughed at pretty much everything in my twenties. During yoga, meditation, hiking, working, etc. It was uncontrollable. I believe that it was part of both my pent-up energy needing either an outlet coupled with a very hyperactive mind and creative spirit. It was time to be distilled, however.

Each night during the Vipassana course we watched video discourses of the technique's leader, S.N. Goenka. He was hilarious and profound at the same time, and it was his deep well of knowledge and understanding that bred his often-unintentional humor. No matter how hard I tried, I could not sit through the discourses without laughing, tears rolling down my face like a waterfall. The harder I tried not to laugh, the more impossible it became to control. I started to wonder if I had an issue with excessive laughter, and I embarked on a mission to become serious (do not try this at home, please). Let me tell you,

laughter is healing and orgasmic in so many ways. I do not recommend trying to douse out the flames of joy and laughter in your life, or anyone else's. Be grateful for this gift of joy, because it is so much more difficult to light this candle again after it has been blown out.

When my first course was complete, I was a different person. I was much more aware, calm, and content. In many ways, the technique acts as an energetic surgery of the mind. It works to distill past karma and unprocessed experiences clogging up the mind's capacity for each moment. Since then, in total, I have sat eleven Vipassana courses, served three, and assisted a Childrens Vipassana course. Very aligned with my poetic and synchronistic life, the next four courses that I sat after the first were all strongly related to an element in nature.

Earth

When I returned home from the first Vipassana course, I immediately looked online to see when I could return for my next course. Having been fairly new to California, I was still obsessed with the possibility of earthquakes. Each morning I checked the USGS website to track where seismic activity was occurring in CA and around the world. I was convinced that we were going to have a huge earthquake in August (1999), so I decided to sign up for a course during that time, to be out of Harm's way, so to speak.

I arrived for my second Vipassana course in early August 1999, back in North Fork, CA. During the first few hours of orientation, while attendees are still arriving, talking was allowed. I immediately gravitated to a girl from Istanbul, Turkey named Sila who was

attending her first Vipassana course. She was 5'2", athletic build, dark curly hair, and deep dark brown eyes. She exuded an obvious sense of sincerity, strength and kindness. We talked for several hours, and tried to make plans to be in the same cabin. I told her about my earthquake prediction, and wondered if we would be informed mid-course if a major earthquake had indeed happened, or if they would allow us to remain in silence.

The course ran smoothly, and we were never interrupted with any news of an earthquake, nor did I feel any tremor as I was expecting (which can often be felt throughout the state when a large earthquake strikes California). On the last morning of the course, as we finished our final prayer called metta, we were allowed to speak again. Sila and I instantly looked for each other to discuss our experiences. As we finished our hug, the manager of the course approached us, saying that they needed to speak to Sila immediately. She was rushed off to the main dining hall to speak with all of the managers. I walked back to my cabin to finish packing.

About an hour later, I saw Sila running down the dirt road that connected the dining hall to our cabins. She looked frantic. I asked her if everything was OK. She said, "No! There has been a terrible earthquake in Istanbul. 7.6 and I cannot reach my family." She ran ahead to her cabin to retrieve her belongings and I never saw her again.

However, what has never left me since is the knowledge of how the Law of Attraction works. It works in infinite degrees of separation. The strong attraction I felt to Sila (and vice versa) was magnetized by the highly energetically charged thoughts of an earthquake in which I was projecting and therefore resonating. Having memories of the future

is called intuition, since the aspect of time is not linear but cyclical and omniscient.

After sitting this Vipassana course, deep-rooted emotions were making their way to the surface of my consciousness. I was beginning the process of mental detoxification, and I was becoming increasingly agitated by emotions from my past that were releasing and strumming my emotional body again. I had several traumatic experiences as a young girl that were never fully processed. I was beginning to think about those incidents more often. Maybe my incessant laughing was a defense mechanism, after all. I was feeling an overwhelming sense of sadness and fear. I wanted to go deeper to understand more, so I signed up for another Vipassana course a little over one month later in September.

Fire

California was experiencing a very hot and dry summer in 1999 and the intense heat was perpetuating into Fall. There were several wildfires out of control in central California. During my northbound drive from LA to the Vipassana Center outside Fresno, I saw smoke and distant fires burning, but I had not yet connected the personal symbolism of this element related to my journey of distillation. It wasn't until the fires grew increasingly closer to the Vipassana Center that the element of fire came front and center. Not only could we feel the intensified heat from the fires, but they were visible from our cabins and we were advised by the managers that we would be evacuated if they continued to get closer. On Day 3 of my meditation course, I was

abruptly overwhelmed with this concept of fire and how that played into the pain I was recently feeling at the end of my last Vipassana course.

Growing up, I was a happy-go-lucky child, for the most part. I was popular, gifted, and a lot of fun. I had aspirations to be a pop star, actress, or attorney/politician. When I was eleven or twelve years old, I began babysitting for a family that lived down the road from where I grew up in Hamburg, NY, outside Buffalo. There were three children, Eric (10), Erin (8) and Charlie Jr. (6). When I first started babysitting at the Mixon residence, I was surprised by the bold displays of hatred that each of them showed towards their father when in private. For example, Erin once played me a cassette tape recording on her portable cassette recorder where she was violently screaming how much she hated her stepfather, Charlie, Sr., who was the birth father for Charlie Jr. only. Eric and Erin were both children from their mother Linda's previous marriage.

Over the next few months it started to become clearer that Charlie, Sr. was mentally, verbally, and physically abusive to both his wife and children. One afternoon I arrived to babysit and Linda was bruised in several visible places, as well as having a broken arm in a cast and sling. She sheepishly said that she fell down the stairs to the basement, but later the children told me that her injuries were a result of Charlie, Sr. who had beaten her. Now I had just turned twelve years old myself, and regretfully I did not know what to do with this information. In hindsight, I wish that I had told authorities, although I did learn later on that Child Protection Services were already informed and involved at that time.

Aside from this pink mammoth snafu, the children loved me, listened well to me and we had a whole lot of fabulous fun together. Interacting with children is truly one of my greatest gifts, as well as one of my greatest joys. In hindsight, it makes greater sense that the children grew very attached to me because of the great fun that we shared together; clearly in contrast to the stressful conflict they were experiencing behind closed doors and when I was not with them.

I grew to love these children and Linda very much, but Charlie, Sr. always made me feel incredibly uncomfortable. He was an aggressive, reactive, and irrational man whose six-feet two-inch presence made my skin crawl. After about one year of babysitting the Mixon children, a very serious situation occurred involving Linda's parents. Linda told me that she believed Charlie, Sr. was responsible for a fire that occurred in her parent's vacation trailer, in which her mother tragically perished, but it was too difficult for her to prove and the police were not being helpful. She feared for her life and for her children's lives.

Seeing the very real danger that she was in, she began the difficult process of separating from Charlie, Sr., who was not happy in the least of this. During this process while she was looking for another home, she and the children were allowed to stay at their home during the week (Monday through Friday) so the children could continue going to school. Charlie, Sr. was allowed to stay at the home on the weekends while Linda and the children would stay with her family members. Neither of them were allowed to deviate from these permissions. Needless to say, I was only babysitting during the week.

When we hit the summer months, there was one particular day where Eric had gone to play with a friend of his at his friend's house. Eric was now 11 years old. Living so close, I decided to take the younger children to my home to swim in our family pool. I left a note for Eric, that if he were to return home he was welcome to join us at my house. After a few hours, Erin, Charlie Jr. and I rode our bicycles back to their home. Shortly after we returned, while I was preparing lunch for them, Erin looked out the kitchen window and started screaming, running in circles and acting wildly. She ran to the front door where unbeknownst to me she had locked the deadbolt. She then ran somewhere where I could no longer see her. While I was trying to figure out what was happening there was a loud banging at the front door. By the time I arrived at the door, no one was there. However, I saw Charlie, Sr.'s pick-up truck in the driveway followed by the sound of glass breaking. Charlie, Sr. broke through a window in the back of the house to enter the home.

Before I knew it Charlie, Sr. was storming into the kitchen as I walked towards the back of the house. I couldn't see either of the children. Charlie, Sr. began screaming at me irrationally, asking me where the key to the freezer was, and then a strange comment that puzzled me. He saw the note that I had left for Eric on the counter. He reacted wildly and started screaming at me for telling his children to go swimming at my house. I was very scared, to say the least, but my primary concern was the children's safety.

To my advantage the phone suddenly rang. Erin jumped out from behind the couch in the living room. She leapt for the telephone, picked it up and began screaming into the phone, "Help us! Help us!" I

watched her recognize who the caller was and continued crying to her "Papa", Linda's father. I saw Charlie, Sr.'s rage triple in intensity, and his face turning red. He aggressively snatched the phone out of Erin's hand, pushing her to the floor. He started to scream obscenities at Linda's father, who was on the other end of the telephone.

I took advantage of this distraction, and picked up Erin under one arm, ran into the living room to find Charlie Jr., likewise grabbing him under my other arm. I calmly told them both to stay quiet and listen to me. I carried them upstairs to their bedroom, sitting down on the floor while I pulled out the board game, Candy Lane. Again, I begged them to please stay calm. After a few minutes, I felt and heard Charlie, Sr.'s demonic energy ascending the stairs. He came into the children's bedroom where we were. Immediately the children scurried and hid underneath the bed. Seeing the children dive under the bed, Charlie, Sr. screamed at me, "You can't even control these children!" amongst other aggressive and obscene words. I stood up fearfully and calmly explained to him that the children were afraid.

The window was opened in the bedroom, and the screen was missing since it had been torn a month or so earlier. Charlie, Sr. focused intensely on me and started moving slowly and aggressively in my direction. I was backing up, moving toward the open window. Everything was happening in slow motion, and I don't even recall what the words were that he was speaking, because his evil energy was overriding comprehension of any words. When I no longer had anywhere else to move, standing against the wall next to the open window, Charlie, Sr. grabbed my shoulders while pushing me towards the window. He shook my shoulders and threatened to throw me out of

the window. By now my head and shoulders were outside of it. As I looked down into the driveway, to my immense relief, I saw a police car pulling into the driveway below.

Eric had been on his way home when he saw Charlie, Sr.'s truck in the driveway. He immediately turned around and raced his bicycle back to his friend's house where he called the police. Eric saved my life, and I will never, ever forget that brilliant and valiant act of an 11-year-old boy. Needless to say, the police filed a harassment charge against Charlie, Sr. for his behavior toward me that day.

Shortly after this incident, Linda found a duplex about six miles away from where she was then living. My parents did not want me babysitting for her anymore, but there was something incredibly karmic about my relationship with these children. We spoke about life, traveling the world, God, the Virgin Mary apparitions, death (I remember Eric telling me that his greatest fear was not being able to breathe), and other deep and hearty topics, in between our wonderfully creative playtime. Often, I would choose a different country, for example, and decorate the kitchen according to themes of that country. I would then speak with a French accent while serving their meals as their personal "garcon," or waiter. I am smiling now, as I type this, thinking of the joy and laughter that Erin expressed when we played so creatively. I can see her long, thin legs bent towards her chest with her feet on the edge of the kitchen table. She pressed her fingertips together quickly and squealed with delight.

Knowing how my parents felt, Linda tried hiring other babysitters to be respectful. Due to the reasons mentioned above, and the children's deep attachment to me, they would intentionally disobey,

and reportedly spit on, any other babysitter. I knew that Linda was having a difficult time, and it pained me that this was making her life even more difficult. I spoke to my parents and we agreed that I could babysit again since she and Charlie, Sr. were no longer living together. When I was scheduled to babysit, Linda would pick me up at my home beforehand – since her house was no longer walking distance – and drive me back home afterwards.

About eight months later, with our new arrangement working out successfully and without any incident with Charlie, Sr., Linda's divorce proceedings were filed. She was dating another man – a man who showered her lovingly and with kindness. She seemed happier than I had ever seen her. Shortly after Valentine's Day I had agreed to babysit for her on a Friday night. I remember vividly the few days beforehand - seeing the red roses, pink colored greeting card, and chocolates that her new boyfriend had given her for Valentine's Day.

Two days before I was scheduled to babysit, however, I got word about a really fun high school party happening on that Friday night with fellow high school students of mine. Being incredibly social and energetic, I really wanted to attend this party. I was the type of girl who could dance non-stop for days, exuded radiant joie de vie, and was always the last to go home. I apologetically told Linda that I was no longer able to babysit, and she kindly understood.

That coming Friday, as planned, I went out with a group of my friends. Around 9:30 PM we were walking through a shopping plaza, when I was overwhelmed with a deeply daunting feeling. I felt like I was in a trance, and I held onto the wall while I started to cry. "I'm going to die, I'm going to die tonight," is all that I could say, over and

over again. This was incredibly atypical for me, and my friends were really in shock as to what I was saying and how I was behaving.

A few moments later a group of male friends pulled up in a car with music blasting loudly from the car radio. They told us to get into the car as they were heading to the party. I instantly refused. They were clearly drinking, and having quickly become overwhelmed with a fear of dying I was not getting in that car. My friends were confused and left without me. Alone, I walked to a payphone to call my mother, asking her to please come pick me up. My mother also found this incredibly odd, given that it was only 10 PM.

Sitting in the passenger seat, I uncontrollably began rocking forward and backward. I was panicked to my core, so much so that I took the rosary beads off of my mother's rear view mirror and clutched them in my hands. My mother asked, "What's wrong with you? Are you drunk?!" I answered, "I don't know what's wrong! No, I haven't had anything to drink. I don't feel good. I am so scared and I don't know why!"

When we arrived home, I walked into the house and fell to my knees on the floor in the living room, still holding the rosary beads, crying, and rocking back-and-forth. My mother appeared very worried, thinking that something was seriously wrong with me. I made my way to my bedroom, crawled into my bed without changing my clothes and whimpered myself to sleep about two hours later.

At 3:30 AM, however, I awoke very abruptly. I was gasping, completely unable to breathe. I fell out of my bed onto the floor, continuing to gasp for a breath. I crawled into my mother's room, still gasping. My mother jumped out of bed, shaking my shoulders, and

screaming, "WHAT IS WRONG WITH YOU?!" She then ran into the bathroom and quickly returned with a towel soaked in cold water. She placed the towel on my head and chest, and I began to breathe again. I collapsed completely to the floor, sobbing in tears uncontrollably. My mother asked me if I wanted to go to the hospital, and I answered, "No." Feeling even more petrified after this, however, I slept with my mother in her bed, since my father worked the night shift and was not home.

An hour later, the phone rang. It was 4:40 AM. My mother answered the phone, concerned at who would be calling at such an hour. It was the Police Department. They asked my mother where I was. I heard her answer intensely, "She is right here next to me. What is going on?!" The police officer explained to my mother that there was a fire at the Mixon home. Linda was a very small, petite woman, and the fire department and police officers thought it might be the body of a young girl instead of a woman. Having noted a harassment charge with my name against Charlie Sr., they were concerned that the body may have been mine.

He went on to explain that two of the three children had also perished in the fire, dying from smoke inhalation ... at 3:30 AM ... the exact time that I was gasping to breathe just one hour before. My precious Erin's handprints were found on her bedroom window in her frantic attempt to escape. Charlie, Sr. was the evil perpetrator responsible for setting the blaze, after he had beaten and abused Linda. He took his birth son, Charlie, Jr. with him before the fire began, and both survived the homicides.

After the phone call, we drove to the duplex Linda and her children shared. I will never forget the moment as we drove up to the house; the windows were blackened and smoke was still rising from the now contained blaze. In one single millisecond, I felt the world color around me and my senses were wildly heightened. I became hyperaware of everything, and not only was that the end of my childhood, but it was the beginning of a massive expansion of awareness. It is difficult to realize what we are not aware of until we are flooded with greater awareness.

Even more strangely, I was able to see what happened that tragic day and night. I saw Charlie, Sr. take the spare key. I saw him dousing the home with gasoline. I saw too much, and it strangely corroborated with evidence that the police had discovered. I didn't know how this information was coming to me so suddenly, nor did I know why I felt the way that I did the night before this horrible incident, or why I behaved in the erratic manner that I did.

I served as a solid witness in the trial against Charlie, Sr. and thankfully he continues to sit in jail today, guilty of murder. This upset was a major turning point in my life. I began acting out in school, dressing wildly, and overcome with feelings that I did not know how to process. I was not offered any assistance in coping with these new, difficult feelings. Luckily, I was a very active person, and I would frequently go into our basement at home and dance until I collapsed with exhaustion. I danced out my feelings, and I began running each morning before school as a means to control / suppress / avoid the intense feelings inside of me. I began to excel in my athletic endeavors

due to this increased drive and physical outlet, with continued attempts to bury my pain and fears.

My goals had now changed drastically. I no longer sought to be a pop star or an attorney; instead I changed my career ambitions to be a social worker, or a dance therapist for abused children. I am not sure if it was conscious at the time, but in hindsight I was clearly looking for a way to heal the inconsolable pain I felt with Erin's, Eric's, and Linda's murders.

Many years later, while I was a Senior at the University at Buffalo, double majoring in Psychology and Health & Human Services with a concentration in Child Development, I was required to complete a working internship at an agency relative to my field. I applied to Child Protective Services of Buffalo and I was accepted.

My direct report, Cynthia, and her team absolutely loved me. They loved how hard working and efficient I was with my internship. Looking back, though, it may have been their sheer laziness that was blowing air in my head with compliments, because they likely knew that it only made me do more of their work for them. Today, I am aware that this is not legal, but Cynthia often sent me out on fieldwork alone, without any supervision. On several occasions, as instructed, I removed children from their deemed unfit homes and delivered them to their appointed foster homes. I did not have a license to do so, but that is clearly an example of how Cynthia was haphazardly giving me her work to do, and I was happy to do it. That is, until I discovered specific information that would no longer allow me to work with her again.

We were walking through a parking lot together, after having gone out on a scheduled home visit together. As we were walking back

to the office, she made mention that the family we visited reminded her of a case she had worked on in Hamburg many years earlier. I reminded her that I was from Hamburg and I asked her to tell me about the case. She began to describe three children and their mother, victims of an abusive father. I didn't even let her finish as she said that they died in a fire. I was already doubled over in the parking lot and I began to vomit. I was crying and vomiting at the thought that I was working for the very CPS caseworker that had horribly failed Linda and her children. Now her lazy work ethic and passing off her duties onto an eager intern were no longer funny or opportunistic; they were downright painful, disappointing and illegal. I never spoke to her again.

This experience is a major reason why I write childrens books today, create conscious childrens toys, and devote much of my time volunteering for social causes related to domestic violence and children's wellbeing. Each time that I am able to bring joy to a child or teach them a tool of self-love, I feel a tear in the corner of my eye and my heart swell with the reminder of the joyous, happy moments I shared with Eric and Erin. This keeps those cherished moments alive, even though I am consciously aware of the real impossibility of having eased or prevented their suffering.

Air

Shortly after my third Vipassana course, now having a clear connection to the symbolism of events happening around me and in nature while I was immersed in these states of intense self-focus, I

started to witness clear patterns and cycles in my life while also understanding the "karmas" and unprocessed energies inhibiting my life's dharma. I was an actor and an observer in the divine play at work through my life, witnessing how the elements around us reveal and reflect our own inner experience. It may go without saying but I wanted to go deeper as soon as possible.

I signed up again for my fourth Vipassana course, and as I mentioned earlier, I sat eleven courses total in a span of the next few years. The specific details of the next two courses escape me, aside from their connection to nature's elements.

My fourth course, which occurred in the Fall, was a period of extreme winds. The winds were so strong that we had difficulty walking around the grounds. Wind can be incredibly detoxifying – stirring up our energies and the emotions that are held within them. I remember consciously allowing the wind to flow through me, doing my best not to resist or fight it, but instead "go with the flow." Many years later, when I was in Machu Picchu, Peru with a local shaman, he purposefully guided us to areas on our excursion where the wind was the strongest. He suggested that we stand with our arms open, legs wide, and facing the wind to allow it cleanse us.

It was during this course that I had two separately profound experiences. Although I had listened to the same discourses in all of my previous Vipassana courses, certain information will grab your attention more at different times, sometimes not recalling that you had heard it before. Goenkaji spoke of Gautama the Buddha, and the process how he finally became enlightened. He told the story of how the Buddha tried every technique, diet, exercise, theory and mantra -

yet nothing was working. It was in the moments when he was finally giving up his endeavors (isn't it always?) that he sat under a Bodhi tree. There he committed to himself not to move or get up until he was enlightened. According to this story, he sat in the yoga lotus position for three hours without moving when he achieved enlightenment and became the "Buddha."

During a Vipassana course, you *sit* for about twelve to fourteen hours each day. After hearing this story, I thought to myself, *Well, I certainly have three hours to try. I have no plans to go anywhere. Let's see what happens.* I crossed my legs into lotus pose and began the morning's "strong determination meditation" in this less than relaxing position. I successfully completed the meditation without moving. I continued staying in my position, still without moving, during the short break that followed, through the subsequent audio exercises, and into the following practice session. I heard my fellow meditators leaving the meditation hall and heading to lunch, which indicated that it was around 11 AM. Having started at 8:30 AM, I knew that I was close to my three-hour goal.

The next twenty minutes felt like an hour. The problem was that I was consciously thinking about time, as well as having developed an attachment to an outcome. Personally, although the sit was incredibly beneficial to my practice, I believe this kept me from truly going deeper into *dissolution*, which is a course objective of the Vipassana technique. Additionally, my legs now were completely numbed from the hips down.

I believe that there is an accumulative effect with any practice, even when we don't feel as if we accomplished our "goal." Later that

same day, after our 6 PM "strong determination meditation," I was meditating very deeply when my body felt incredibly hot before it actually lifted off of the ground as if struck by lightning. It felt as though I was in an imaginary car that hit a bump in the road, throwing me off of my seat. When I realized what happened I was taken completely by surprise, having fallen back down and to my right side. It only lasted a matter of seconds. I felt intensely light and incredibly alert at the same time.

I sought to find out more about what happened and stayed after my session to inquire with my teacher. She suggested what Goenkaji called "bhanga," which is known as "the fifth insight." It means "knowledge of contemplation on dissolution" and one can often feel a burst of lightness. When I inquired on what I should do next, she merely replied, "Keep sitting."

When I returned home to Los Angeles after this course, I was flooded with excessive stimulation and hyper-awareness to a level of deep discomfort. I was still teaching yoga at Maha Yoga. Other people at the studio began talking about the obvious shift in my behavior. I remember the strong feeling that everyone around me was living a lie. I felt so confused as I was sensing their feelings and thoughts – sometimes even hearing them – yet their actions and words were completely disingenuous to what I was sensing. I began spinning with anxiety from the disconnect. My intuition was too finely tuned to be surrounded by any kind of hypocrisy.

It's quite rare that we can reach out a hand to someone in a state of agitation or anxiety, speaking the perfect words to relax them into a grounded and more relaxed state of being. This was what I needed, and

strangely enough, this is what I received. The owner of the studio, Steve Ross, saw what was happening to me and he spoke words that instantly halted the anxiety that was plaguing my consciousness. He said, "Alanna, people meditate their entire lives to get what you are experiencing and you're afraid of it. You're not going to lose 'Alanna.' You're not going to lose your laugh or your funkiness. It's who you are, so just relax." For whatever reason these words did the trick, and I did just that. Relax your mind and open your heart. Let the wind blow through you and dissolve into Spirit. I was forever changed.

Water

As I began acclimating back to LA life, I quickly felt disconnected from the growth I was making with my meditation practices. You have probably heard the reference that it's always easier to find enlightenment alone in a cave, and I wanted to go back in. I was addicted and hungry for this deeper comprehension of reality. Additionally, during the past few months I started developing a passionate relationship with a fellow yoga instructor, named Rick. I was shy and avoidant of his advances, but enamored by the energy and attention that he was lavishing on to me. I was equally excited and uncomfortable at the same time. Rick was aggressive, narcissistic, and seemingly oblivious to his actions – as if he truly only lived each moment and quickly disregarded the past while refusing commitment to the future. This confused and intrigued me at the same time.

A few weeks beforehand this instructor, Rick had discovered that I was also a yoga instructor and that I taught at a studio owned by a

teacher who he greatly despised. After finding this out, his behaviors towards me quickly changed for the worse; I was no longer a weak and potential groupie, but now a competitive threat. I have matured to realize how I would act out as a younger and less confident girl. I acted awkwardly when faced with disconnected inauthenticity, unable to voice the direct reason for my discomfort, instead appearing as the projected oddity although merely responding to someone else's aggressive behavior.

Now that I am older, I can not only look back at my own life as a young woman, but also witness other young women falling into a common trap. We feel that we have to reciprocate sexual advances from men, especially older, powerful, and aggressive men. Biologically we can often confuse what *feels good* with *what feels right*. In this instance, the element of spirituality became woven into the sexual energy. One may translate this as a soul mate, and the other an apres-yoga mate of the day.

During my clinical training at university, I learned how sex abuse victims often disassociate with sex to a degree where ironically, they become hyper-sexual, sexually manipulative and/or sex workers. The early sexual activity can awaken both sexual power and biological pleasure, but it is often laced with confusing feelings of fear, shame and guilt. These feelings can deny greater intimacy in mature and loving relationships.

Rick would often caress my body in "adjustments," and it felt good. Realistically though, I recognized that he was a predator. I just didn't have the confidence and maturity to separate my youthful desire for attention from my logical understanding of how predators

manipulate. I became addicted to Rick because our connection turned me on, but I was always left feeling empty and confused after each class. Conscious intimacy, mutual understanding, or even consent to groping me during class were all missing. My strong spirit knew not to trust his intentions, but my indulgent immaturity wanted more candy. That was the awkward struggle that he grew to despise because my spirit wasn't easy.

Instead of addressing Rick's behavior, I shut down or "froze" around him as a form of protection, thus appearing to be the awkward one. Additionally, as a young woman I didn't want to turn down the sexual advances and energy that he sent my way, even though I was not interested in pursuing a romance with him (mostly based on how many women he was sleeping with). I was not yet empowered in my feminine independence and I still played the codependent cat and mouse game of seeking sexual attention from men.

Rick kept a bed in his back office and slept with several women each day after his classes. The truth was that I was turned off by his behaviors, as he ruffled my bubbling Shakti and pro-woman purpose, but I was still confused and trying to find my position. I struggled to separate this innocuous attraction from logical self-protection and confidence. As a result, my signals back to him were confusing, on top of my refusal to jump into the "Chosen Yogi Bed." This began to anger him.

I became a bit obsessed with this situation, partly because nothing manifested in the material realm, while it also mirrored a dysfunctional and abusive relationship that thankfully didn't manifest. It was easy for Rick to now dismiss me, projecting me as worthless for

not wanting to sleep with him. I, being the philosophical Feminine, wanted to process this intangible experience with him. Hence the tension between us became palpable.

I was still traveling to San Diego a couple days per week to practice with my Ashtanga teacher, Tim Miller. During class with Tim one night, in final resting pose, he told us a story about Shiva (known as the masculine aspect of consciousness). He was breaking down the word Sava-sana, meaning death pose, and stated that Shiva without Shakti (known as the feminine aspect of consciousness) is Sava – dead. I raised my head and propped myself onto my elbows, stirred from my rest. I asked him, "Then what is Shakti without Shiva?" His answer was immediate, "She's just fine," he said, implying that men need women more than women need men. I smiled and laid back down to rest.

My fifth Vipassana course was set during the subsequent winter. The entire ten days of the course we experienced a very severe downfall of rain. As I write about this now, at a time when California is in a severe drought, I am reminded that our winters were indeed a rainy season, with this year extremely wet. That was the most intense rain that I have ever experienced while living in California the past twenty years, and it was perfectly cleansing in both my individual process while also continuing to be poetic in my reflections with nature's elements. As I have illustrated thus far, I was diving into very intense inner work in a very short period of time, hoping to seize the accumulative benefits of deep Self-realization.

I sloshed through the rain and mud, walking from my cabin to the meditation hall and down to the kitchen each day. My rain boots filled quickly with water and my umbrella barely deflected the rain

enough to see where I was walking. My heart was heavy and full of sadness and emotion. I felt embarrassed for how Rick had treated me in the last month, and how foolish that I wrongly appeared. Since I had not responded to his sexual advances, he acted in ways that made me feel shamed and worthless.

During one of my meditations around the fifth day of the course, I began drifting into a past memory. The Vipassana practice does not encourage daydreaming, but there are inevitable times that this becomes difficult to control, and ironically healing "a-ha moments" can sometimes result from this mental hooky. In this instance, I felt a very familiar memory of being in my mother's womb as a growing fetus. I saw a dark yet opaque orangey color, as if light was passing through my mother's body and into her womb. I could hear my mother's voice, which was soothing and nostalgic. I felt very much at peace.

I continued sitting and observing these feelings, memories, and visions as they arose in my mind and consciousness. I sensed no time at all. Then quite suddenly, however, the memories were gone. Everything in my mind became black and silent again. I remained aware of this empty space for at least fifteen minutes, still sitting, listening, witnessing; without adding or wishing for anything other than what I was naturally experiencing.

Then again, suddenly, this changed. I was back in memory of my mother's womb, except this time it was very different than twenty minutes earlier. I felt my mother's energy very clearly and I heard her voice for certain, but the opaque color was not present – I only saw and felt blackness. I felt different as well, beyond explanation – just very different, as if I was someone else. I remained witnessing this state of

being for at least ten, fifteen minutes more, feeling my furrow scouring on my face.

After five minutes or so, I was jolted with an extremely negative feeling and an abrupt lightning bolt-like energy. The feeling was clear as day. "Get out! This is a boy!" I felt, while whisked back into the silent, black space of uncertainty, void of sound, feeling no body at all, with no connection or awareness of my mother. I continued this meditation session for at least another hour, disregarding the discourse practice sessions being played over the loudspeaker. I felt no further sensory changes, feelings, or visions related to this memory of any kind.

After this course, during the four-hour drive back to Los Angeles, I phoned my mother in Buffalo, NY. I told her about my experience, and how cool it felt to have re-visited the memory of being in her womb, before I was born – as that is how I had perceived my experience; almost like a past-life/early-life regression. I lightheartedly told her about the strange disconnect and rejection with being a boy. Jokingly, I said that maybe my older brother, Tommy, and I were twins after all.

You see, when I was about five years old, I was absolutely convinced of a story that I told my family repeatedly, sometimes growing furious when others would laugh at me sharing it so earnestly. I shared with them that my brother had "cut ahead of me in line while we were in Mommy's tummy together." To this day I can feel the deep conviction that I felt of this story, but I cannot explain it with realistic concepts or terminology in any way. I was furious at my brother for cutting ahead of me, because I was supposed to be born first! I explained how I grabbed onto Tommy's leg (while we were in the womb, that is), holding on tightly as we struggled pre-birth as to who

would be born first. I finished my story by telling whoever would listen that I then chased after him with great fury, being born right after him as a result.

Now, although I remember feeling absolutely convicted of this being true, there are a few facts that raise an eyebrow when you think about them: 1) My older, only brother, Tommy, has a birth defect on one of his legs, making that leg longer than the other. The defect created a strange red streak mark on his calf, 2) My mother had a very long, very difficult labor with my brother, 3) My labor was so fast, short and strong that the nurses physically held my head from coming out because the doctor had not yet arrived at the hospital for my birth.

Now, do I believe my childhood story in a literally sense? Not necessarily, but I do believe there is great synchronicity in it – and I do believe that there is some spiritual relevance to it all. My brother has always been competitive with me, consciously and unconsciously usurping my achievements for his own.

As I was talking back on the phone with my mother, she grew very quiet. I asked her if something was wrong, thinking that I had offended her with my meditation practices again (the terminology and practices reminded her of my deviation from Catholicism which was still difficult for her to accept). She sounded very serious, and said, "Well, I have never told you this before, but I had a later term miscarriage right before I became pregnant with you. I was about four months along and suddenly miscarried for no apparent medical reason. It was a boy, and we named him Todd."

We were both silent, and I couldn't stop wondering if this was related in any way. Was my passionate desire and relevancy to be born

as a female related to this? Was my brother a spiritual, antagonistic twin (his name "Thomas" means "twin" in Greek and several ancient languages)? Was he trying to one-up me when we separated, in an egoistic desire to be born first? Did I choose my parents specifically, waiting for the perfect time and conception to be born? Many other questions flooded my mind as I pondered these synchronicities after having virtually swam once again in the water of my mother's womb.

All in all, during this Vipassana course, I was left with an overwhelming sense of gratitude for the continuation of nature's elements in four consecutive courses, as I will admit that I was fearful that with each course, the symbolism would cease, at least as obviously as they appeared to me, or that I would be too distracted to witness them.

In hindsight, it is interesting and appropriate to have ended this elemental cycle with water. As my body (earth) began to crack open during my second *sit*, the surge of chaotically passionate emotions began bubbling to the surface (fire). Maintaining consistent practice and focused awareness continued the prana, or flowing life force to sweep through my consciousness (wind), which added more fuel to the fire with more conscious participation. So as not to overheat or self-combust, the water seemed to grace me at the perfect time, cooling the rocks, soothing my broken heart. It steamed out a peaceful sense of gratitude for my unique life and existence. This was matched with a deep sense of humility and self-realization that my life did have meaning. I mattered.

Chapter 3

"When I find myself in times of trouble Mother Mary comes to me, speaking words of wisdom: Let it be." –The Beatles

Fatima, Portugal

My trip to Fatima, Portugal, has been rooted in spiritual serendipity as far as I can remember. I was born on Friday, October 13th, a date holding significance in the Catholic faith as *The Miracle of the Dancing Sun*. It is one of the only recognized miracles accepted by the Catholic Church. In 1917, in rural fields of Portugal known as the Cova da Iria, as many as 100,000 people assembled together in order to view a miracle prophesied by three local shepherd children. All who were present claim that after a wild fit of rain, the clouds opened and the sun appeared brighter than ever seen before. It then began to move

in a slow zig-zag pattern and eventually appeared to be crashing towards the earth. People who were wet from the torrential rain stated that their clothes dried instantly and the muddy grounds around them were also dried. Many who were present with ailments or disease were instantly healed.

The Virgin Mary had appeared to these three children (Lucia, Jacinta, and Francisco) in Fátima, Portugal, on several occasions earlier that year, with the first known appearance on May 13. There she told the children that she would appear to them on the 13th of each month for the next six months, ending October 13th, in which there would be "a miracle for all to see, and for all to believe."

As I mentioned in the Introduction, my mother has always been incredibly devoted to the Virgin Mary, and while other children my age were read standard fairy tales before bed and fantasized about trips to Disneyland, my brother and I were exposed instead to the prophecies of Nostradamus and the worldwide accounts of the Virgin Mary apparitions. I absorbed it all with great fascination, and grew up seeking to understand both the science and magic alike.

When I was nineteen years old, I had planned a European backpacking trip with several of my college friends. Our itinerary was thorough; I would travel with my friend Tai from New York to Germany, followed by Belgium, the Netherlands, Italy, and France. From there we took a train to Barcelona to meet up with two more undergraduate friends, who were working there for the summer teaching English. Once together, we planned for our group to travel to Madrid and Sevilla, ending our journey back in Paris.

We had nearly completed the circuit and were enjoying a wonderful holiday in Sevilla, Spain, when I woke up one morning with a crystal clear, uncontrollable intention. It baffled me at the same time, but I now realize it was another episode of angel hacking. Much like the trance-like state I encountered in Kindergarten, when I walked to the altar in church to be blessed with the name of Mary, something was telling me to go to the city of Fátima in Portugal, alone. I was surprised as I'd never had any previous thought to go there, and I was shaking with the thought of separating from my friends and traveling solo as a young teenaged girl through Europe.

Earlier in this trip Tai and I had travelled to Lourdes, France - another site associated with Virgin Mary apparitions. There it is reported that the Virgin Mary appeared eighteen times to Bernadette Soubirous (the same St. Bernadette of my childhood church) at this grotto in Lourdes. I enjoyed visiting the site, but my friend Tai showed great lack of interest while we were there. This reminder solidified my decision to reroute my trip to visit Fátima alone. My friends were to travel on to Paris the following day, and I told them I'd meet them back home in the US. My friends were understandably worried and shocked that I wanted to make this journey alone, and I will admit that I was frightened as well, but something beyond my comprehension overrode my fears and reason.

The journey took twenty-six hours by train. It was a long, spontaneous journey that wasn't thought out well, and resulted in a 9 PM arrival at the Fatima train station, without plans for accommodations or knowing what to expect. I was brimming with both nervous energy and excitement. I was the picture of an American youth

- bright eyed, pony-tailed, wearing a tie-dye shirt and clutching the side straps of my backpack - as I took those first eager steps off the platform onto Portuguese soil.

The train station was filthy. There were no attendants working at the station, nor any travelers. Outside there were a handful of sweat-soaked Portuguese taxi drivers smoking and lingering by their taxi cabs as they awaited any remaining fares for the night. They leered at me openly, and I grew very uncomfortable very quickly, sensing the color draining out of my face. Had I made a fateful mistake? Had I been too rash to follow this inner pull to come to here? Goosebumps crawled uncomfortably along my skin as I felt their eyes raking up and down my body.

Again, I had no plans or itinerary (these were the days before cell phones or the Internet). I gripped my backpack even tighter and searched to find out more information on getting to Fatima. I nervously approached a driver and asked him, "Which way is Fatima?" He shook his head and spoke quickly in Portuguese. I didn't understand a word. I had a similar exchange with the next few drivers, and I grew increasingly anxious. Finally, a driver spoke to me in French - slow grammatical French, at that. I felt relieved, as I had taken French all through high school and could get by with the basics. I wasn't fluent, and while Parisians spoke far too quickly for me, I understood the taxi driver well enough.

"Vous parlez Français?" *Do you speak French?* he inquired. "Oui!" *Yes!* I answered with excitement. I eagerly asked him how I could get to Fatima. He informed me that the actual village of Fatima was 25 km away. I made the quick conversion in my head: *15 miles.* Oh no! He

went on to say that all of the shuttles were finished for the day and only taxis were available. I asked the price of a cab ride to the Cathedral and back, and it was far out of my backpacker's budget. I was dismayed, but chalked up the efforts I made to get here as the best that I could do. I thanked him and walked back inside the station to see when the next departure train was arriving.

During that short time that I was outside talking to the taxi driver, no other trains had stopped at the station. It was a very small station and I had already seen all of the people there, for certain. Yet, as I walked back in, and out of nowhere I heard two female voices speaking American English. I was washed over with sheer relief as I set my eyes on two young American women. Both numbing and exhilarating at the same time, I took a moment to be sure it wasn't merely an oasis of wishful thinking before I hurried over to them.

I introduced myself and I was kindly received. I was further amazed to learn that both of these hip-looking ladies before me were nuns in Mother Teresa's Missionaries of Charities order. To this day I smile at the meaningful coincidence of their names. The blonde woman with the robust laugh was Shamrock and her taller, regal friend was Theresa. How incredibly fortuitous and settling to run into them - it seemed that my luck was certainly turning around.

The nuns were in their mid-twenties and working as traveling nurses. They were on vacation, and exploring more of Europe before heading back to India. Shamrock had curly, dirty blond hair. She was from Kalamazoo, Michigan and she had a gregarious nature that put me instantly at ease. Later that night she told me about her motorcycle

excursions throughout France – just to illustrate that this was not your typical Catholic nun; this was for sure.

Theresa was soft spoken and gentle. She was extraordinarily tall and very pretty. I explained that I'd just arrived, but that I was not able to make it into town to visit Fatima. I went on to explain that I needed to change my flight and get back home as soon as possible. In order to do this, I needed to contact my airline. I was flying on a student's fare which allowed for last minute changes, if available. The only problem was that I only had an AT&T calling card - which wouldn't do me any good since Portugal was only wired with MCI at that time. While ushering me to the payphone close by, Shamrock reassured me not to worry. She graciously let me borrow her MCI card. Not wanting to impose any charges on her account, though, I used it only to get a connection to an operator, where I then requested a transfer of the charges to my mother's phone back in Buffalo. I instructed the operator to request my mother accept the charges for the call I needed to make to my airline.

As I waited on the line, I heard the phone ring, and then my mother answered the phone. I heard the operator ask my mother if she would **"accept the collect call from Alanna,"** instead of **accepting the charges for Alanna's transferred call.** My mother frantically accepted what she thought was a collect call, and then I was transferred to my airline customer service number. I made the necessary flight change, and thanked Shamrock again, not even realizing the devastation my mother was now experiencing after accepting a collect call from me in Europe, followed by a dead line.

I was awash with relief now that I'd secured my ticket back home, and more critically, I was no longer alone in this foreign country. The girls and I were getting along famously. We laughed together while cleaning up in the bathroom, doing our best to freshen up. The girls were catching a later train to Porto, and I asked if I could join them. My flight wasn't for three more days out of Paris, so I could travel with them and at least see the city of Porto. They kindly welcomed me into their group.

As we exited the women's bathroom, the French speaking taxi driver I'd spoken with earlier approached us as we sat outside. He smiled warmly at us, and gestured across the street while asking if we would like to join him and his friends for a glass of wine. We looked at each other agreeing, "Why not?" We accepted. The train Shamrock and Theresa were taking wasn't until 2 AM, so we had quite a bit of time on our hands. The four of us along with three other cab drivers walked across the street, entered the venue and sat down at a table in the middle of the bar.

"It's such a shame you won't be able to see the Cathedral after coming all this way," they mused. They continued to tell me about the sites at Fatima. The taxi driver was listening and he picked out the bits of our conversation that he understood. He already knew I was seeking to visit Fátima. He then excitedly stated that he was planning on going into town to pick someone up and return them to the train station for a midnight train. Why don't I come along for the ride and at least see the sites through the passenger seat window, he suggested. It honestly sounded like a brilliant idea. I was thrilled. Shamrock and Theresa also

thought it was a great opportunity and offered to watch my bags while I was gone. I accepted both of their offers.

I left with the taxi driver around 10:30 PM, leaving my backpack with my new friends. After my quick drive-by sightseeing adventure, I would return to the station and on to Porto with them. Everything was working out after all! However, the moment the cab door shut, I immediately felt nervous. The brilliance of the idea instantly drained out of me as I realized I had willingly entered a vehicle with a virtual stranger in the middle of nowhere. I became hyper alert, paying attention to every sign and fork in the road. Although I was becoming increasingly nervous, I did not have anything to base these feelings on, so I tried mentally talking myself out of worrying.

That is, until he decided to stop at a coffeehouse. This is when my fearful suspicions started to become justified. He pulled into the parking lot and casually told me that he was going to get an espresso. I glanced at the time - it was 11:15 PM. I could have sworn he'd said his passenger needed to catch a midnight train. *Maybe I had misunderstood the times with our language barrier,* I again tried to convince myself. Maybe, he meant that his passenger didn't need her pick-up in Fatima until midnight. When he returned to his cab fifteen minutes later, we continued driving another thirty minutes through the rural Portuguese countryside.

The Cathedral bells began beautifully chiming midnight just as we arrived. There were quite a lot of people walking about. I was surprised there was so much activity at this hour of the night. The driver told me he would return to pick me up in thirty minutes, and to meet him in the same location. The thought persisted that his passenger

would have missed her train, but I clung to the faint hope that I'd simply misunderstood. What choice did I have?

I distracted myself with the beauty of the Cathedral. Inquisitive as to why so many people were gathered, I came to learn that I had arrived on the birthday of the Virgin Mary, precisely as it was being celebrated - midnight. The size of the crowd now made sense, and I was beyond thrilled that my spontaneous drive-by trip had turned into the opportunity to be here, now, in the presence of this perfect, celebrated moment. I thought it was incredibly synchronistic that I was born on the Feast Day of this Marian apparition, only to arrive at the exact moment of Her celebrated birthday.

Although it was only thirty minutes, my time at the Cathedral will always be cherished, especially given the slim chances of how I was able to experience it. While I was entering the Basilica, I met a young seminarian named John. We talked while taking in the sites, we prayed, and he walked me back to where I was meeting my driver. I remember clearly as he took my hand in his and said, "May God grant you safe travels." I thanked him, and equally wished him well in his life and service.

I then turned to the grinning driver who was waiting for me, holding the taxi's passenger car door open. The cab was empty. My heart sank, fearfully, and I asked, "Où est la femme?" *Where is the woman?* The driver responded to the effect that she had too much baggage. Trying not to look alarmed, I got into the cab, thinking how odd this was, yet still trying to hold on to the possibility that I am just not understanding the translation properly. The calm sense of peace I'd

held moments before evaporated as we drove away from the Cathedral, without an additional female passenger as he had suggested earlier.

Instead of driving back towards the train station, however, he began driving around the small town. He pointed out the homes of "les petits enfants," *the little children* who had witnessed the apparition in 1917, as well as other historical sites related to the Fatima apparitions at that time. Besides all of this being very peculiar, there was a part of me that wished I could openly appreciate the unrequested extended tour, yet I could not muffle the unease prickling down my spine.

His conversation also turned more peculiar and inappropriate, asking me about the age at which women in America become pregnant. I pretended not to understand, and I leaned closer to the passenger door. My mouth became dry and my blood pounded in my ears as he repeated the query in a different way. Again, I didn't respond. The language barrier was there, but the crux of his question was clear. At what age did American women start having sex, he was asking me.

I was terrified. I stared straight ahead and spoke very little in response to his questions, but he drove terribly slow and stared at me while driving. I was paying attention to each and every turn, and each and every road sign. As we approached a distinct fork in the road, the one which I recalled from our departure to Fatima, my stomach clenched as he turned in the opposite direction of the train station. At this point it was now one o'clock in the morning. From the "wrong" turn, he turned his cab down a dark, dirt road, drove about another ¼ of a mile and stopped the car. I was frozen, using one hand to feel for the pocketknife in my fanny pack.

The driver then scooted his body over towards mine and began making sexual advances on me. I pushed him away from me, screaming at the top of my lungs as he continued his attempts to grope me. I screamed, "A le train! To the train station!" He taunted me, leaning in as I yelled for him to stop. I reached for the door handle, but frozen in my mind, because where was I going to go? I was in the middle of the woods somewhere, not a light shining, nor did I speak a stitch of Portuguese. He pretended to start the car again, only to stop suddenly and attempt his advances again, laughing as I flinched at his movements. My mind became furiously intent that *this was NOT going to happen!* I heard myself snarling in a low, threatening, fierce and guttural tone, "A. LE. TRAIN. MAINTENANT!" *TAKE. ME. TO. THE. TRAIN. STATION. NOW!*

Now he was frozen. He looked at me with a dead expression for a few seconds longer and I continued looking straight ahead. I would not even give him the satisfaction of looking at him. And just like that, he stopped. He started the car and drove me back to the train station. We sat in silence, as I glared ahead, projecting myself to the train station. He made no further advances at me.

As we pulled up to the train station, I saw my two new friends praying on their knees, clutching rosaries. I sprinted from the car and ran to them, relief coloring their faces as I approached. Every part of my body was trembling. "We have been so worried about you," Shamrock said. "When you didn't return, we knew something was wrong, and we have been praying for your safe return since the train left here at midnight." By this time, the 2 AM train to Porto would be arriving at the train station within minutes. Acknowledging this, we gathered our

belongings and ran inside the station. Once on the train, knowing that I was no longer in danger, my hamstrings began to shake uncontrollably as I stood, realizing what had just happened and the wild array of emotions I had felt. I certainly was very lucky to have an angel friend named Shamrock, and the irony of her name goes a very long way.

A few days later, when I arrived back home in Buffalo, my mother told me how she had been absolutely wracked with fear and worry. I had not spoken to my mother before I chose to detour my trip to Portugal, so she was startled to hear from an MCI operator, especially when she knew that I had an AT&T calling card. It goes without saying that the situation was aggravated when the "collect call" she accepted didn't go through, and she didn't hear from me again. She'd been absolutely beside herself, and being the mother that I know, went to church and began praying feverishly for my safety.

With the choice of calling the FBI or going to mass to pray, my dear mother, Joanne, would always choose going to mass. It had been 3:30 PM EST (9:30 PM in Portugal) when I had made the call to her. After waiting a couple more hours for me to call back again, she went straight to church for the 6 PM mass (12 AM in Portugal – exactly when I was arriving at the Cathedral). There, she told me, she threw herself onto her hands and knees in front of the altar and prayed for my safety.

And it was in that moment, when my mother was explaining her actions, that I had this massive epiphany of startling clarity. *This is how prayer works*, I concluded. When I arrived in Fatima, I did not have financial means to drive into town. I was instead offered a vehicle to experience Fatima and the Virgin Mary's birthday celebration. I had angels protecting me both at the train station and back at home, praying

for my safe return home. Their energy and fervor protected me in a dangerous situation.

This illustrates one of the many beauties of embracing our dharma. Money can often hinder our dharmic expression because we can control and pay for exact specifications of our lives, leaving little to the uncertain or miraculous. If we can refrain from labeling experiences as bad or good, and furthermore from reacting to our judgments as a result of attachment or aversion, we will see that everything is a vehicle to fulfill our journey. It can be very frightening at times to open up to these infinite worlds of uncertain possibilities, but this is where magic often occurs. The energies of your innate desires are always working in your favor, if you allow them to unfold. I think it is obvious that I took a huge risk, throwing caution to the wind, that absolutely could have turned out more tragically, yet there is a part of me that is grateful my passion and trust was greater than my fears. However, I hope never to burden my angels to that degree ever again.

Fatima / Bridge to Islam

This year (2017) is the 100-year anniversary of the Miracle of the Dancing Sun at Fatima in 1917. Personally, I have always loved the connection of Fatima, the town in Portugal where the Virgin Mary appeared and Fatima, the daughter of Muhammed, founder of Islam. The name Fatima comes from the Arabic word "fitam" which means "the one that is kept away from evil and bad character."

The Koran has many passages concerning the Blessed Virgin. She is mentioned in the Koran more than in the New Testament of the Bible,

and she is the only woman mentioned by name in the Koran. Many Muslim women look up to her as an example and she is revered in high regard by many Muslim men. According to the Koran, Allah (God) chose Mary above all women of all nations. Could her appearance in the town of Fatima be a bridge for mankind to separate our religious differences and come to a unified spiritual understanding of love and peace?

There is a divinely poetic undertone to ISIS, both 1) the acronym used to indicate the modern day Islamic militant and terrorist group, and 2) the Egyptian Goddess myth stemming from the Sumerian Goddess Inanna, who was likely an Annunaki alien and part of the first "royal family" to rule humans on Earth. Inanna fled the Middle East after conflict with other Sumerian gods. She settled in both the Indus Valley (India) and later Egypt, where similar myths of winged (or multiple armed) goddesses also emerged (Durga, Kali, Isis, and Ishtar, to name a few). All travel with a lion and hold the ankh / omega symbol that came to represent both Goddess, Feminine, and the Libra constellation. Many popular Goddess festivities are held during the Libra moon cycles.

I see a connection to the sacred anger of women who have been suppressed worldwide for generations upon generations, and the ignorant anger of those desperately trying to maintain such unjust suppression and control. Mahatma Gandhi lived during the same time as Adolf Hitler. Blended together there is a manifest dance of light and dark that may be part of this Leela experience. Likewise, could ISIS terrorism then be part of the Goddess revelation unfolding today, as the

dark, suppressed shadow of ignorance? After all, stars are born in the dark and all darkness is expelled by the light.

Chapter 4

"The ego is only an illusion, but a very influential one. Letting the ego-illusion become your identity can prevent you from knowing your true self." – Wayne Dyer

Machu Picchu

It was October, 2001, and my friend, Virginia, had recently attended one of my surf & yoga retreats to Costa Rica that I organized with my dear friend, Chase. Virginia asked me if I was interested in organizing a retreat with her, to Machu Picchu, Peru. Naturally, I said *yes*. We agreed to do an exploratory trip together in October, and coincidentally it would be my birthday while we were there.

Peru is an enchanting South American country. Its ancient civilizations were highly intelligent, and history shows their cultures to have been courageous and hearty, imbued with mythology, passion, and intrigue. Its landscape consists of arid coast, mountain plateaus,

and Amazon rainforest, making the perfect backdrop to an eclectic and diverse part of its history. The Andes run parallel to the Pacific Ocean, having some of the world's highest peaks reaching elevations over 22,000 ft.

Flying into Lima was amazing; the air was clear that morning and looking out from the airplane I could see the jagged snow-covered peaks. We flew from Los Angeles to Lima, Peru where we spent one night before flying to Cuzco, where we would acclimate to the high altitude for a couple of days before traveling on to Machu Picchu. Cuzco is one of the highest cities in South America. The altitude in Lima is 5,080 feet, Cuzco is 10,800 feet, and Machu Picchu is close to 8,000 feet.

We landed in Lima on October 12th and our flight to Cuzco was scheduled in the late afternoon on October 13th. Knowing that we only had one day in Lima, I planned to get up very early the next morning and walk around Peru's capital, and hopefully find a Catholic mass to honor my day of birth.

The next morning, I left my hotel around 5:30 AM. The concierge at the hotel lobby was a beautiful woman with a golden olive complexion, dark almond shaped brown eyes, and light brown wavy hair that fell to her shoulders. She had a professional demeanor and was eager to assist me when I approached her. I explained that I wanted to celebrate my birthday at a Catholic church. She gave me the name and directions to one close by.

I exited the hotel and turned in the direction of the church which she had recommended. The weather was cool and dry. I was wearing a pair of jean shorts and a t-shirt. As soon as I stepped foot onto the street,

I was incredibly surprised to see it filled with people at such an early hour. Nearly all of the people were wearing purple clothing, and some of them were walking barefoot. I had not one single clue as to what the celebration was, but I was quickly awakened by the vibrant energy at such an early hour, and very interested to discover more. I continued walking towards the Church of the Nazarenes, which is where the concierge had suggested I go.

When I arrived at the Church, there were maybe twenty to twenty-five people in the entire church. The church did not have any seating whatsoever; no chairs, rows, or pews. There was only a large area where the people gathered to attend Mass or stand in prayer. However, the rustic colonial architecture was breathtaking. I was taking in the artwork in the church, the beautiful flowers and the smell of incense when I noticed more people entering the church increasingly fast.

Within minutes the entire church was completely packed. When I say packed, I mean tighter than two coats of paint on the wall. Every part of my body was touching the people on each side of me, and vice versa. I quickly felt claustrophobic and was rushed with a sense of panic, but Mass was beginning and there seemed to be an end in sight. I tried my best to breathe and relax.

During Mass, people were sending their personal belongings and rosaries to the front right corner of the church. There, a deacon or altar boy touched their possessions to a painting and the items were passed back through the church to the owners. Naturally, I followed suit and had my rosary sent forward to touch the painting.

I wasn't able to follow along with the sermon, as I am not fluent in Spanish, but I was relieved to sense that the Mass was finally ending. I was doing everything possible to be patient in such uncomfortable circumstances. However, instead of exiting the church, *more* people began cramming *into* the church. What appeared to be a Cardinal (assuming by his attire and headdress) walked out from the vestibule and stood next to the altar. He appeared to be preparing for yet *another* mass. *How was I going to get out?* I thought. Sensing my internal panic rising again, I reminded myself that I didn't have anywhere to rush off to. I tried to once again relax into my situation and take in the extended ceremony that I had stumbled upon.

The Cardinal appeared to be offering a special blessing next to the painting that was sought out for blessings of personal items earlier. He was holding the monstrance of the Eucharist and reciting prayers while an altar boy dispersed incense towards the painting. I closed my eyes, opening my heart to celebrate in what appeared to be a very special event. I figured that I would try to understand more of this later on, with help from my English-speaking concierge.

I felt the Holy Spirit, which I often do in Mass. I felt peaceful, strangely, even amidst the near-suffocating, tight, foreign quarters. Just then, while in prayerful rapture, I felt someone touching me ... on the front of my pants. I quickly opened my eyes, trying to see what was happening. I obviously could not run anywhere or shift away, and I can only assume that the short, old bald man in front of me knew this, leading him to try to diddle me in church!

I have only shared this story with two people before, for obvious reasons; it's a little embarrassing. Not that this is an excuse in any way,

but remember that I was fresh out of five Vipassana courses. Major premises and practices of Vipassana are 1) being non-reactive, and 2) non-judgmental. I was caught completely off-guard in a very unique situation that did not allow me to run away from or shift out of. For the first couple of minutes, I was merging the spiritual expansion with the physical stimulation, until I realized the reality of what was happening. At that point, realizing what this five-foot, sixty-year old, pervert was doing, I nearly climbed over and plowed through the crowd to make my successful escape, hopefully causing no harm to anyone along the way. Later on, though, I did ponder the unconventional irony about the combination of spiritual ecstasy and sex, and the ability to channel such powerful forces into prayer.

When I returned back to my hotel, I asked the concierge about the festivities that occurred at the Church of the Nazarene that morning. She told me that in Lima, October is known as El Mes Morado, the purple month. They call it this because purple is the color worn by the faithful who follow the processions of the most venerated religious image in Peru: El Señor de los Milagros, the Lord of Miracles, a uniquely Peruvian image of Jesus Christ.

She continued explaining that in 1746 there was a massive earthquake (8.6-8.8 magnitude) in Lima causing nearly complete destruction of the capital, and a subsequent tsunami devastated a nearby port city. It was the deadliest earthquake in Peru's history prior to the 1970 earthquake. The majority of buildings were destroyed or affected in some way, except for a single painting of Jesus on a mural that was found completely unharmed and unaffected, amidst all of the rubble around it. This is how the image came to be known as the Lord

of Miracles, and the celebrations are also known to be one of the largest processions in the world. Every year in October, people participate in this religious procession in which the image is carried through the streets of Lima. It was certainly a jackpot morning to go to mass for a quiet 6 AM solo celebration of my birthday.

When I returned to my room, I didn't tell Virginia or any of the others who had joined our trip about anything that I had just experienced. I only had time to take a shower, grab some lunch, and head to the airport again, en route to Cuzco. Here we would meet our personal guide, an intense, self-proclaimed shaman named Kuyichi, a word derived from the Peruvian god of the rainbow who brought color to the world.

Cuzco is a city in southeastern Peru, near the Andes mountain range. The site was the historic capital of the Incan Empire from the 13th until the 16th-century Spanish conquest. The Constitution of Peru designates it as the historical capital of Peru. When we arrived, we all felt dizzy from the higher altitude. Once at our hotel, we were offered cocoa leaf tea, as well as dried cocoa leaves to chew. These are natural remedies for altitude sickness.

Kuyichi was also waiting for us at our hotel. He had long, course straight black hair, dark almond eyes and a strong hooked nose. He was medium to tall with a strong athletic build. He carried himself proudly with a strong, incredibly confident presence and posture. He had a dramatic way of speaking, and although he was very knowledgeable on Incan history and architecture, there were times where he seemed to be making up odd stories as he went along, seeming to enjoy when people believed him.

Immediately I felt something deeply inauthentic about him and I grew skeptical. He appeared an enigma in many ways, which intrigued me, but I felt it was a conscious choice on his part to cast a mysterious tone. It matched the image that he chose to present; that of a Peruvian shaman Rainbow god who had insight into the ancient Mayan worlds.

Having a raw, unleashed intuition, I doubted many things that Kuyichi shared with us throughout the trip, even though he had been a guide at Machu Picchu for over fifteen years, and was a teacher of tourism at the Cuzco Institute. Virginia's personality was less reality-based than mine, to put it nicely, and she was drinking every word of the Kool-Aid that Kuyichi spoke. For that very reason, I kept my skepticism to myself and went along with the flow of things during our trip, especially since many things that Kuyichi did share with us had verifiable merit. He used this to establish his authority and believability.

As you can probably imagine, he didn't like when I asked questions or challenged his hocus pocus, and this increased the already existing friction between an aware, intelligent woman and an aggressive egoist man. What egotistical man spewing his own illusions wants a reality-based woman to question his façade? For example, after he explained what his name meant, I asked him if that was his birth name. He answered confidently, "Yes," while looking me straight in the eyes, with a subtext of *do not question my divine authority*.

A few days into our trip, however, as we were walking through the village of Cuzco, a woman's voice called out from across the street. "Irwin!" she yelled while running towards us. When she approached, Irwin, er, Kuyichi introduced us to his sister. I never questioned him about this, or made even a slight energetic dig because I found no value

in embarrassing him. It was purely information to build my experience with him. It was also the proof I needed that a young boy named Irwin, raised in Cuzco, dreamt up the persona of an Incan King named Kuyichi. He is committed to the dramatic flair of his "character," and I do find this admirably entertaining. However, even though I was interested in his intuitive nature and spiritual inclinations, "Irwin" cast great doubt upon his veracity.

After our first morning excursion with Kuyichi, he told me that my animal totem was a hummingbird. He explained that hummingbirds exude joy, move and think very fast, travel through all dimensions of time and space, and live on nectar. At that time in my life I was eating mostly fruits and honey. I could see a correlation to this totem. He went on to say that the ancient Incans built the city of Machu Picchu in the shape of a hummingbird. I really appreciated this thoughtful symbolism, and like many people I know, I am drawn to magical hummingbirds when I see them in nature. Kuyichi had a way of balancing his out-of-this-world theory with personal spiritualism and historical fact. The latter two tactics blended out the former by establishing your trust in him as being the interpreter of your fate. This, matched with esteemed knowledge, carried over into the innocuous nonsense.

The day that we set out to climb Machu Picchu was misty and radiant. The high-energy vortex of Machu Picchu is both scientific and spiritual, due to the mineral-rich soil composition. There are higher levels of copper, iron, and zinc in this region, making it a great conductor of electricity, as well as the archeological and historical components of this extraordinary city. Invisible from below and

completely self-contained, Machu Picchu is surrounded by agricultural resources sufficient to feed those who live there, and it is watered by natural mineral springs. Archeologists agree that it seems to have been utilized by the Inca as a secret ceremonial city. Shrouded in the clouds, the ruins contain palaces, baths, temples, storage rooms, and at least 150 houses, all in a remarkable state of preservation.

When we arrived at the base of Machu Picchu (meaning "Old Mountain") the night before embarking on to the ancient ruins, we all enjoyed a dip in the naturally hot thermal spring baths, Aguas Calientes. Here we soaked our muscles before the next morning's early climb. You could see the underground sulfur springs bubbling up from the rocky ground. I have a deep affinity for hot springs, both physically and mentally, and was thoroughly enjoying this natural mineral soak.

Kuyichi wore a small black Speedo, proudly showcasing his "package" while swaying his long black hair (which reached down to his lower back) behind his puffed up, broad chest and chin as he swaggered from pool to pool like an ancient Incan king. I have always been very strong, both physically and mentally. I too, paraded my muscular, toned physique around the pools, intentionally deterring any attention towards Kuyichi. I could sense that this bothered him, which merely added to the ego-fueled tension between us.

The next morning as we were preparing to depart our hotel for our day-long hike of Machu Picchu, I realized that I had forgotten the unthinkable: hiking shoes! I had only two pairs of shoes to choose from: 1) flip flops and 2) Born brand wedged slip-on dress shoes. Since the weather was nippy and cool, I decided to wear my dress shoes to hike.

As we gathered early at the base of Machu Picchu, I allowed a moment of deserved roasting as everyone took turns commenting on my sketchy choice of footwear. I laughed it off and metaphorically clicked my dress heels three times. That is, until we began the climb. Being at such high-altitude results in higher levels of condensation, which covered the rocks and walkways. Without rubber-soled, grip-bottomed shoes, each step felt like an extreme-sport thrill forcing me to pay attention to every shift of weight or risk falling. Fortunately, however, something very unexpected resulted of this unintentional walking meditation. I became hyper aware of my surroundings and deeply immersed in each moment while walking these sacred grounds.

Walking meditation is also known as mindful walking, and it is an active practice that requires one to be consciously aware while moving in their surrounding environment rather than sitting down in meditation with their eyes closed. In hindsight, I was able to, for the first time, emphatically relate to my extreme sport addict friends, who had told me of their rock climbing, sky diving, and mountain jumping activities leading to a heightened sense of being; they were forced to be present because they couldn't focus on anything but what they were doing, or risk great injury or even death.

Every color was doubly vibrant, every sound was part of a greater symphony, and I was overtaken with humble awe of the multi-dimensional majesty and history I was walking through. Research excavations were taking place in a specific, closed-off area, where the ancient skeletal remains of a young girl were recently discovered. Kuyichi, being a professor at the Cuzco Institute, had authority to be approved access beyond the yellow tape of some researchers and

archeologists working on Machu Picchu. Since we had a smaller group, we were all allowed to view the remains up close and observe their research process. It was incredibly fascinating.

Researchers have been collecting ancient human DNA from Machu Picchu in efforts to determine what the function of "the lost city" was for. According to Brenda Bradley, an associate professor of anthropology at the George Washington University, Machu Picchu was too big to be a local settlement but too small and not the right structure to have been an administrative center for the Inca Empire. The prevailing hypothesis among researchers is that Machu Picchu was a so-called "royal retreat" – much like what Camp David is for the White House – where Inca Emperor Pachacuti would have visited and held diplomatic meetings.

As we continued along away from the researchers, Kuyichi stopped at a breathtaking area overlooking vast mountains and valleys. He reached into his pocket, pulling out a small tub of dark-colored paste and a plastic baggie full of crackers. He dipped a cracker into the paste and handed one to each of us. "This will enhance your spiritual experience," he said. I asked what it was. He answered that it was "an ancient super power herb that only grows in Peru."

Ironically, at dinner the night before, Kuyichi was dramatizing an ingredient listed on the package of a nutritional bar offered at the hotel. The ingredients were listed in the ancient Quechua language, which derives from an indigenous language in the Peruvian regions pre-dating the arrival of colonial Spaniards. The word was kinuwa. He acted as if it was the most powerful, high-protein seed on the planet, the "mother of all grains that gave ancient Incans great strength and

power." Hey, I was sold; I bought five bars! Later that night, however, while checking my emails at the Internet café in the lobby I decided to research this power food, kinuwa. Turns out it was **quinoa**. Yes, I agree it is a healthy grain, but I wouldn't have hyped it up to the level Kuyichi did. This gave me a clear reference point for the many insinuated, super-powered, and esoteric contributions he added to many of his stories and explanations during our tour.

Keeping in mind his tendency towards exaggeration and dramatically unfounded theory, I disregarded his spiritual paste as nothing more than crushed olives. I ate the cracker and paste without need for further explanation or hype. I was hungry, after all. The taste was horrible. I wanted to spit it out, but I didn't want to be rude; nor was there an appropriate place for me to spit. It tasted musky and bitter. Ick! I was chasing it with half a bottle of water when he continued, "It's Ayahuasca." My eyes widened. I had heard of this plant, and thought it may be associated as a recreational drug of some sort, but I didn't know much about it. Given my power struggle with Kuyichi, my pride wouldn't let me ask him for greater details as to what it was. We merely continued along with our magically mindful tour of Machu Picchu.

About twenty minutes later, Kuyichi's energy grew a little manic. His explanations now jumped from iffy to absurd. Shortly after, I also began feeling feisty, both physically and emotionally warm from the inside out. For example, we entered into an area that was clearly an ancient birthing chamber. Aside from the obvious physical structures indicating this, a tour guide ahead of our group was describing this area in that manner. Yet, when it was our turn to enter and explore this area, Kuyichi had a wildly different theory that he shared with us. He began

speaking in low, almost whispering tones of secrecy. He stated that growing up in this region since a young child, he spent many teenage nights sleeping at Machu Picchu, listening to the ancient culture and downloading information far truer than what researchers or tour guides relay.

He continued that this area was not a birthing chamber, but a communication reflector to the Gods once covered in a sheet of solid gold. The presumed-to-be foot holders of the presumed-to-be birthing chairs were in fact, Kuyichi said, "where hand-held lasers were placed when one entered the communication center." Now, Virginia and the rest of our small group were eating up his story - outlandish details and all - making sounds of fascination and delight. I however, had just been slipped a bit of mind-enhancing herb and I was losing any remaining strength left to bite my tongue. My eyes were rolling left, right, and center.

Our next stop was at the Palace of the Princess, and here Kuyichi told me to follow him alone, which I did, leaving our group behind. We walked into publicly marked unauthorized areas, where he led me to one room in particular. He told me that this was once my bedroom when I was the Incan Princess Chamu. I looked at him, a little shocked and confused. *Huh?* He told me that he had a vision about me, and that he now knew it to be true. I started to laugh, which seemed to upset him. He continued that he was going to leave for five minutes alone in my now ancient bedroom, and that I should lay down to meditate so that my memories could be restored.

My instinct was that he was trying to feed my ego – you know, implying that I was an Incan princess (who doesn't love hearing that

they were or are special in some way?) in efforts to win me over, gaining my admiration while minimizing my resistance to his malarkey. Coincidentally, however, the ayahuasca was kicking in. The room felt like it was shaking and I felt a little dizzy, so I laid down where he had implied my sleeping area once was.

My mind started speeding one hundred miles per hour and I had no way of controlling it. The first things I saw were wild animals around me – large snakes, onyx black jaguar, and large birds with both colorful and solid white feathers. My body felt heavy while my mind felt like it was trapped in a kaleidoscope. I felt an urgent sense of panic, seeing myself searching for a means to escape whatever was haunting me. My shoes were woven slippers and my long black hair was finely braided. I wore gold cuffs on each wrist and turquoise beads around my neck.

My heart stopped in absolute fear at the sound of a tribal horn blowing through my ears. I immediately turned into a lion, leapt onto the stone brick ledge, over two men approaching my room and into the jungle behind them. What seemed like an hour was apparently five minutes. I regained consciousness to my surroundings, finding myself curled up on a floor of rock and shale, drooling at the mouth and trembling from both my visions and the chill from the cold stones below me.

In hindsight, I do wish that I had been more receptive and grateful of the visions that Kuyichi shared, instead of being so distrusting and challenging. My skepticism, rebellion to ego, and fear all masked themselves as mirrored arrogance. I did, however, willingly follow his instructions to rest on the rocky ground inside the room of

Princess Chamu, perfectly timed with a mild hallucination of an Incan woman in the same room fleeing danger in the form of a lion.

I was born rebellious to male aggression and ego. Most all of my archetypes and symbolism reflect warrior goddesses or strong-willed woman of some form defying inequality, objectification, and ignorance. At some point, however, I would like to learn a softer, more compassionate approach to dealing with these issues. As from this example I just shared, there is value and purpose with these extreme opposites, and in mythology it is often the dragon that transported the goddess. Kuyichi, I mean Irwin, offered me both a gift (even if it was a tactic of manipulation), and an epic experience, despite our energetic resistance and inability to see eye to eye. However, at this current state of my life, the idea of acquiescing or passively accepting the behaviors of a narcissistic man sends shudders down my spine, filling me with feelings of weakness and disgust.

I pondered the necessity for opposites, thinking of the man fondling me during Mass in church. I thought about Jesus Christ, and how few recognized the prophet and "Messiah" in a poor and humble carpenter. Why do we need an inflated image in order to be recognized? The Israelis expected a royal king, not realizing that a true Son of God cares not about worldly robes or a superficial image.

I thought about The Alpha and the Omega, and if the Alpha is the First and Masculine, then the Omega is the Last and Feminine, much like the Feminine Revelation happening worldwide today. We, too, globally portray a "goddess" as a glamorous, sexualized woman. We quickly dismiss the idea of a humble woman with a deeply divine knowing as a goddess.

The ancient practice of Tantra was the first to worship a female aspect of God, and it was pure in its origin. Man, however, quickly sexualized the practice - as our world then (and now) views women as sexual objects, oftentimes overlooking the passionate, intelligent, creative, and multi-tasking activists seeking the make the world a better, more unified place to live. If a female Messiah were to grace this planet as the Omega to the Alpha, she too may be overlooked and likely rejected by worldly masses who cannot see beyond the superficial image.

At this time in my life, I accept myself as the rebellious and defiant warrior goddess, perpetually ascending to break the ever so distant glass ceiling of Goddess misconception. I AM the Alpha and the Omega, both within myself as equal parts. I am far more than a sexual object, and the time saved from playing these baseless roles grants me the experience and wisdom to be a true leader and role model to women, if they too can break their chains of objectified value and worth. I am liberated from seeking a co-dependent other to fulfill the sacred, divine formula of enlightenment. I stand committed not to be manipulated by old, ignorant paradigms surrounding masculine and feminine gender roles. Regardless, Irwin, thank you for the mind-expanding, royal experience.

Chapter 5

"Maybe you are searching among the branches, for what only appears in the roots." -
Rumi

Kali-fornia

In the spring of 2003, I was living in Rancho Santa Fe, North County of San Diego. During this time, I frequently led week-long and weekend yoga retreats which I called "Goddess Retreats." These were all-female, juice fasting, yoga & hiking retreats in high-energy, vortex-rich locations worldwide (Sedona, Maui, Desert Hot Springs, India, etc.). During these weekends, while secluded in our hot springs accommodations, we often grew so comfortable with each other and our shared intention of self-acceptance, that clothing became optional. This was before the surge and craze of plastic surgery and

Photoshopped images that we see today. I believe that women are growing more insecure with their body image as a result of these trends, more than they did during the time when we relished being naturally hot and beautiful. Let's be straight, elective plastic surgery can be weird. It's more of a mental turn-on than physical, because realistically we usually know that it's fake.

It's easy to look like a Barbie doll. The modern-day recipe for "sexy" includes breast and butt implants, a nose job, Botox, lip and facial fillers, hair extensions and weaves, false eye lashes, fake nails and heavy make-up. Anyone can fix this recipe – man or woman, and much like a Louis Vuitton bag, people carry their silicone baggies as if they are better people for having them. What all of these ingredients have in common is that they cover and fill, potentially and temporarily distracting us from natural realities and emotional voids. Similar to any attachment (sex, drugs, alcohol, food, etc.), a faux surge of confidence follows when stimulated by these state-altering substances. Knowing that someone went through the effort to alter themselves equates to a higher probability of having sex with them, plain and simple. Here lies the dysfunctional and delusional sexual movement we're in today, confusing our future generations, skyrocketing STD's, and creating deeper addictions.

Similar to Master Frodo in *The Lord of the Rings*, women hold the ultimate ring of power and control over what is defined as a sexy woman. Sadly, however, the majority of women have been led to believe otherwise (that they are powerless) and therefore succumb to the ignorant trends in our societies today (ex: sexual objectification and/or sexual submission). If women truly embraced their natural

beauty and sensuality while respecting their value as powerful, feminine human beings, men would have no choice than to follow their example (as some do, thankfully).

I am certainly not denying the magnificence and artistry of beauty, or subtle plastic surgery (if one is willing to gamble all of the risks), because I also know that gravity is not always our friend. However, applying the understanding of asteya (the aspect of non-stealing) as defined in Patanjali's Yoga Sutras to illustrate that when one's obsession with image overrides self-love, health, personal authenticity, personal purpose, and environmental health, it lacks integrity.

I personally find natural women infinitely more attractive for a couple of reasons: 1) because they are real, and there is no accomplishment associated with plastic surgery as there is with loving oneself, as you are, and 2) natural women tend to be healthier, therefore radiating greater happiness, which is truly as beautiful and sexy as it gets. Scar tissue diminishes energy flow. We are live, energy beings and living with toxic silicone bags and scar tissue inside one's body diminishes energy flow, as well as overall systemic functioning. It may suit some women to diminish their heart chakra vibrations – they may fair better in business and/or less love-based sex, but it may be a hearty price to pay to block the exquisite feeling of being loved for who you are.

Years ago, I was taking a yoga class at the studio I taught at, Maha Yoga. This was during that time in my life filled with excessive, awesome, spontaneous laughter. This studio was known to be a bit of a scene, and one woman in particular came to class every day. She had

the whole fake kit and definitely part of that scene. We were practicing next to each other on this given day. The superficial scene wasn't for me; I just loved the light-hearted fun, great music, and spiritual vibes and I easily overlooked the superficial. I wore no makeup, simple fashion, you know; exactly as I am. As much as I appreciate creative fashion, dressing to impress or in efforts to maintain or project an illusion of higher status is mute to me. I am far more driven to discover natural dharma, synchronicities and truths within myself. For one thing, I find the former far too easy. And secondly, it throws me off my path and down a rabbit hole of more forced, fake experiences.

As I was rocking out in crescent pose, she turned to me with a furrowed brow and squinted eyes of resentment. Her clenched jaw moved only to mutter out the words, "How can *YOU* be happy?!" Of course, it was meant to be hurtful, as dark, self-hating people always seek to douse out the light of truly happy, loving people. It did hurt a little, because I knew she was trying to imply that I was unattractive, but the pain of her insult was quickly overridden with empathy for her life situation; that she was so attached to looking a certain way that she couldn't see the sunshine mixed in with the clouds.

I believe one major reason that our natural resources are rapidly diminishing worldwide lies in that individual desires outweigh the needs of humanity as a whole. Greed is an epidemic, sadly, and it doesn't take much to seduce someone to reveal how selfish they can become. It takes conscious effort to live with a unity consciousness mindset. This is what will create a greater humanity.

What this all comes down to is integrity and self-realization. It is obvious when a car is stolen from its parking space, and we can use

physical evidence to convict someone of the crime. Trademark attorneys, likewise, work to protect the intellectual properties of those who own them. Yet, the world-renowned "guru" that I worked for with a long list of sexual harassment charges and plagiarism lawsuits defies public detection because our society enables predators and praises ego. Witnessing others who are unceasingly obsessed with their image, spending their precious energy and life trying to look like someone else is encouraged in nearly all aspects of media. Sadly, my own "friends" have knocked off creative concepts that I have shared with them, and I watch the domino effect of posting content on social media. People are hungry to "feed their feed" and your creative post is a sitting duck if it means being liked, or getting a "like." Globally, our less evolved monkey-minds are still dominated by what we can take from the outside world instead of what we can organically give back to our communities and world.

Patanjali states that desire is the root cause of any form of stealing (be this a physical possession, persona, facial feature, or even assuming the ideology or creative concept of another as your own); the practice of asteya is focused on simple living. The objective of yoga is to become self-dependent, self-empowered, authentic and harmless beings. Anytime that you need someone or something to feel a certain way, you are in a co-dependent and disempowered relationship. Selling sex to fill a void or an underlying insecurity is completely different from loving playfulness between respectful and conscious partners. Self-respect = Higher Love.

Shasta Calling

I kept a map of California pinned on the wall to the left of my desk and a globe to the right, as I was always ready and willing to travel to the next energy eddy, especially if there was symbolism or history to enrich my Goddess within. On this particular night, I was having a *Sleepless in Rancho Santa Fe* kind of a week, for some unknown reason. I was repeatedly waking up around 3 AM, unable to fall back asleep. After the fourth or fifth night of this unusual pattern, I actually got out of bed, walked to my desk and began to write. I wasn't writing anything in particular, just writing down how I was feeling at the time.

As I looked to my left, my eyes locked onto my map of California - more particularly, onto Mount Shasta. At 14,180 feet, its elevation is higher than Machu Picchu. I felt inexplicably drawn to it. Invigorated by the spontaneous inspiration, I began to do some online research about Mount Shasta, and I was very intrigued with the spiritual and natural writings listed about the town and mountain. Artifacts discovered on Mount Shasta and the surrounding areas suggest at least 11,000 years of human habitation. Apparently, Tibetan monks sought out the energy in this area, visiting once a year for meditation. I was greatly intrigued and the research was enough to tire me. I returned to my bedroom and fell back to sleep.

The following night, I again awoke at 3 AM. I once again sat down at my desk, and this time when I looked at my map, my eyes became riveted on seven different cities. My eyes followed those major California cities from the base of the state to the top. I scanned up and down until I realized the similarity in pattern to the seven yogic energy chakras within our energetic bodies. These yoga chakras associate with major organ functions (ex: heart, colon, etc.). Out loud I said, "It's Kali-

fornia!" altering the spelling of the state after the goddess, Kali, who rules the first chakra. After all, California is reportedly named after an African Queen, Califia, and the state seal features the Roman goddess, Minerva, on its crest.

From the base of the state, near Mexico (where I was living) to the crown of the state along the Oregon border, Mount Shasta, there was a pathway of ascension that fascinated me. There are countless stories, legends and myths surrounding Mount Shasta, adding to its mystery and allure. Native Americans have long observed Mount Shasta as a sacred mountain. They viewed the mountain and its surroundings as holy ground; thought to be one of the first earthly places created by the Great Spirit. In the past, no one but medicine men or women climbed up the mountain beyond the tree line. It was thought to be too powerful for ordinary people to visit, and inhabited by hosts of potentially dangerous spirits and guardians who could harm a person who traveled up the mountain unprepared.

The next morning, I called a close friend of mine, Bobby, the absolute epitome of the masculine adventurer, rugged outdoorsman, and nature-lover. He was a passionate, health-conscious man; tall (a touch over six feet), handsome, thick wavy brown hair, a square chin, and deep brown eyes. We became fast friends with our wild experimentation and mutual fascination with health and detoxification. Together, with our friend Ryan, we often competed on who could intravenously take in more ozone gas, made our own komucha and kim chi, took handfuls of herbs and pills daily, hiked, climbed, and soaked in sense-deprivation tanks. I was a staunch vegan at the time, and enjoyed raw fruits and vegetables in juices, smoothies, and as whole

foods. Bobby and Ryan also enjoyed raw foods, but they were not vegan. They shipped raw buffalo organs and meats from Wisconsin and ate them raw, often chasing them with a few raw eggs. We both saw our diets as "healthy," and we both respected each other's food choices.

I told him that I felt a calling to go to Mount Shasta. He answered without hesitation, "Let's go!" He tickled my intrigue even more by telling me about the numerous sightings of the ascended master, St. Germain, on Mt. Shasta, who was the entity surrounding the "I AM" movement, philosophy and community in the area. Ascended masters are spiritually advanced beings that manifest and assist human evolution. A more common name for them are "saints," however not all saints are ascended masters. Obviously, with a great affinity for the great I AM, and a yoga company called AZIAM, I was excited!

In less than a week, Bobby arrived at my home in San Diego in his white Bronco, ready to ascend Kali-fornia. Together, he the extreme masculine energy, and I the extreme feminine energy, drove through all Kali-fornia Chakra's from the base to the crown – complete in less than 11 hours. Along the way, I took note of the centers and cities, and how they matched the energy of the Yogi Chakra system:

First Chakra – San Diego

We began the journey in San Diego – The **Muladhara Chakra**, and Earth element. This energy center represents our "roots," including the abundant soil in which we root ourselves. The energy of this center focuses on family, security, and abundance of mind, body, and worldly possessions. Having lived in San Diego for many years, I

felt that these characteristics were very spot-on with the city's energy and communities. I lived in Rancho Santa Fe, known as the richest community in America. The area is very family-oriented, abundant / wealthy, and community driven. The first chakra is associated with the large intestine, where we draw the abundant nutrients and fluids from the soil of our food. Although most (if not all) major cities offer colon-hydrotherapy services, San Diego certainly has a strong industry hold of this offering, including the very well-known Optimum Health Institute.

I came to live in San Diego in a very Alanna-fashioned, synchronistic manner. A private client of mine, who lived in San Francisco, came into possession of a seven-million-dollar home in Rancho Santa Fe, in default of a lawsuit victory. When the internet first hit the public's hands, Gary acquired numerous one-word domain names: love.com, sex.com, match.com, etc. While he was building the match.com empire, a man illegally forged a document transferring the sex.com domain to himself. That man went on to build a billion-dollar porn site with it, unbeknownst to Gary for several years. When the fraud was discovered, Gary won a lawsuit against the IP thief, and the domain provider, who allowed the illegal transfer. When the defendant lost in court, he ripped up his home in Rancho Santa Fe and illegally crossed the border to Mexico, to avoid paying what was owed to Gary, which was over sixty-million dollars.

Gary asked me if I was interested in living in the home's guest house and help to repair it back while he traveled to and from San Francisco, Los Angeles, and San Diego. I happily agreed, as I was already driving to San Diego weekly to practice with my Ashtanga

Yoga teacher, Tim Miller. I kept my home in Los Angeles (which was in Topanga Canyon) and moved to San Diego, living half the week in each city.

While in San Diego, I applied for a job at La Costa Resort. I was hired as a yoga, Pilates, and fitness instructor, as well as private trainer in the Athletic Club on property. The members were very successful, wealthy people of all walks: fashion designers, producers, real estate moguls, etc. I quickly established roots into the North County San Diego community.

Second Chakra – Los Angeles

The earth element merges with the water element and source, in the second chakra. The **Svadhishthana, or Sacred, Chakra** represents this flow and fluidity in the forms of creativity, passion, pleasure, and intimate relationships. It is located in the pelvic region, associated with our creative reproductive organs and emotions. While the First Chakra is satisfied with survival, the Second Chakra seeks sensual pleasure and enjoyment. You wouldn't even need to drive through Los Angeles (as we did) to recognize this connection – LaLa Land is the land of fluid illusions, sensuality, creativity, and of course, Hollywood.

I moved to Los Angeles when I was twenty-three years old. I had booked an ABC movie-of-the-week, which was going to be a big jump in my acting career, moving from commercials to TV. It was shortly after moving to LA that I decided to no longer pursue acting. In contrast to NYC (where I was living and had studied), there was less focus on the craft, and more on shades of peroxide and fillers. I was turned off by

the superficial, and contemplated moving, but I felt that I could successfully hide in LA, where it is acceptable to be a narcissist. With everyone so self-obsessed, I could live unseen, which suited my newfound interests in yoga and meditation. When I created AZIAM, I consciously stated that no one would direct me or tell me who I should be. My only job was to discover who I AM, and to play the best, most authentic version of myself that I could.

Bobby was an actor and model. We were clearly attracted to each other, but he had a deep aversion to intimacy and fear of losing control. He had the body of a Marlboro Man, which he posed as in the infamous ad, and the attention span of a toddler. In other words, his bad boy meets nature man was extremely attractive and eternally intangible. My grounded feminine acceptance coupled with wild child sense of adventure, made a perfectly illusionary attraction based on young passion, sexual tension, and wanderlust spirit.

Third Chakra – San Luis Obispo

The **Manipura, or Solar Plexus Chakra** is located at our core, and represented by the fire element. It is known as our power center. The elements of fire involve processing food in our stomach and pancreas, as well as the fire element to process life's experiences. The energy around this chakra results in a healthy self-esteem, willpower, self-discipline, and equanimous joy - maintaining a neutrally happy state of being, regardless of circumstances. Our truest nature is joy.

Just as we passed through the northern regions of Santa Barbara, Bobby and I developed a severe case of the giggles. We were laughing

for no reason in particular, to the degree where pain and pleasure merged. My stomach ached and tears ran down my face as we howled laughing, at absolutely nothing. We hadn't formed a conversation about our laughing spell when we saw a sign for San Luis Obispo, and underneath the city sign read: "Happiest Place in America." We looked at each other and laughed even harder – this was perfectly resonating with our happy mood, and in hindsight, recollecting the experience, with the Manipura Chakra.

Stopping for a quick bite to eat, we decided on the iconic Madonna Inn (named after the Madonna family, not the pop star), a very pink and whimsical roadside inn that dates back to the late 1950s. In the foyer of the Inn, there was a wine and cheese offering. We were greeted by a concierge named Peter, who told us that *he* was the happiest person in all of San Luis Obispo. He shared with us that the secret to happiness was being present. He said that happiness is a state of being, independent of circumstance, status, or possession.

After a short and joyful tour of the grounds, Peter gave each of us a healthy lunch box to-go, after seeing that we skipped the free wine and cheese offering in the lobby. When we asked how much we owed him for the food, he answered, "Nothing. Happy people enjoy giving gifts. Thank you for stopping at the Madonna Inn and have a safe drive to your destination tonight."

Healthy Food + Laughter + Kindness definitely made this The Happiest Place in America for us that day.

Fourth Chakra – San Francisco

Continuing our feverish climb north, we ascended into San Francisco, where "love in the air." It was around five o'clock when we started through the city regions. The fire element is absorbed by the air element turning into the fourth chakra, **Anahata**, or heart chakra, emanating from our unconditionally beating heart, fueled by our air-consuming lungs. This chakra vibrates unconditional love and compassion. It is the matrix center where we feel the infinite bonds with other beings, a sense of caring and feelings of universal love, altruism, generosity, kindness, and respect. Named after St. Francis, a man who dedicated his life to loving service and compassion for all beings, it is fairly easy to see how this enchanting city may romance you to "leave your heart in San Francisco."

When we spend quality time with people, it often becomes more possible to get beyond the ego layer of our shells to develop true friendships. Bobby and I are both Libras, and during the eight hours traveling so far, we began settling into a sincere friendship. It was enjoyable to be road-tripping with him. I smiled when I looked at him, not in a *I want to rock you sexually* kind of way, but in a *I like you* kind of way.

Unconditional love is the most scarce and immaterial resource there is. It's not something we can ask for or work at. It's not something we are guaranteed or have the right to. It's only something that we can earnestly give and it's the most coveted of all resources. It's easy to forget that we are just passing through this world, and so we put emphasis on possessions and status when all we have to leave behind is how we've made others feel.

Bobby turned on the radio and tuned in to a local station. A

perfectly timed, widely-known Journey song was playing, *Lights*. "When the lights go down in my city..." as the sun was starting to set down over the Bay. I considered how nice it was to have great company on this Journey called Life.

Fifth Chakra – Sacramento

The air element of the heart chakra begins to dissolve into ether. As we passed through San Francisco, we discovered the fifth chakra fairly quickly. The **Vishuddha Chakra,** located in our throat, is our "voice." Our larynx creates harmonies, vibrations, and sounds that allow us to communicate how we feel, what we desire, and our perceptions of each moment. It reminds us to live true to who we are, to express ourselves truthfully beyond any limitations of time, space or personal conditioning.

After hearing the classic Journey song and singing our hearts out, Bobby and I continued passing the time driving by rocking out and singing to the songs playing on the radio. That's when we reached the voice of the California state, none other than the capital, Sacramento. After countless Schwarzenegger jokes in Austrian accents, we spotted a sign for a Karaoke bar. Bobby and I looked at each other and smiled in a non-verbal agreement. He pulled off the freeway and towards the bar.

The vibe was old-school. Frank Sinatra and Tony Bennett songs echoed through the venue. The crowd was older, and seemed to be enjoying their "Happy Hour." The line to sing was short, so we blasted out a few tunes each: *Sweet Caroline, Hotel California, Manic Monday,* as well as *Don't Go Breakin' My Heart* by Elton John. It was a lot of fun, to

say the least, and additionally it felt great to sing and laugh so freely while wildly impressing our over-sixty audience. When we finished, we refreshed our drinks, emptied our bladders and jumped back on the road to Mt. Shasta.

Sixth Chakra – Napa Valley

We were now embarking on the Napa Valley vineyard country, which appropriately matched the **Anja Chakra**, or sixth chakra, represented by the "third eye" in alignment with the pituitary gland, placed between and above our eyebrows (but in the center of our brains). Much like alcohol, ether can influence the mind, awakening a "sixth sense," or intuition associated with this chakra. The color associated with this area is violet. As we passed through the colorful red grape vineyards, I was reminded of this psychedelic, mind-enhancing power.

Moreover, as we passed through Redding, CA, we saw signs indicating the direction of Eureka, CA, a town twenty miles west on the Pacific coast. I found it most fitting to experience an "a-ha" realization about this chakra upon seeing Eureka. We were entering the ether-induced Purple Haze, Purple Rain, psychedelic experience of rich vineyards and state-altering wines, except without any substance to alter our state of being.

The energy of this chakra allows us to experience clear thought, become intuitively connected to Higher Truth, as well as deeper spiritual contemplation, which the serene peacefulness and vast natural beauty of Northern California landscapes definitely breed.

We chose not to stop at any of the vineyards or sights through this region and continued to our destination, hoping to complete the journey in record time. Instead, we both felt overcome with silence and presence, enjoying the scenery. Be here now, for there is only here and there is only now.

Seventh Chakra – Mount Shasta

Under eleven hours from our early morning departure from San Diego, Bobby and I rolled into the magical area of Mount Shasta, a town developed around and named after the potentially active volcano, Mount Shasta. The word "shasta" means "chaste," or "pure," much like the pure Crown Chakra, or **Sahasraha.** I was completely and instantly mesmerized by the peaceful, majestic, and light energy I felt upon reaching this area. My antennas for spiritual receptivity were definitely up! This energy chakra is associated with our pineal gland, above and behind the pituitary gland. It is illustrated at the crown of our being, connecting us with the universe and the light source of creation broadcasting though us. Accumulating all color from the base chakra to the crown, the colors merge to create pure white light. There is a feeling of mystical unity and the selfless realization that everything is connected on a fundamental level.

The pineal gland acts in two ways to inhibit the action of the pituitary gland. First, the pituitary gland is responsible for activating adolescence and the beginning of sexuality, and the pineal gland checks the pituitary gland to prevent premature sexual awakening. Second, human thought is regarded as a result of suspended action, and the

pineal gland inhibits/regulates the immediate discharging of thoughts into action, or re-actions. This inhibition causes us to look inward and to deeply ponder our actions and reactions, creating consciousness.

This introversion is indispensable for self-realization as it displaces our attention from the outer world to the inner. When the external world disappears, our circle of consciousness contracts because our primary attention is focused upon our inner self. It is this inner attention that magnetizes "spiritual light" into the pineal gland.

There was an accumulation of sexual attraction building between Bobby and I as we drove the length of California together, deeper and greater than the attraction that was there previously. We had never acted on our attraction, but I had an overwhelming feeling that I would enjoy our energetic attraction more than a physical act of passion. We visited a hot springs spa and lodge next to the Parks Creek River. We both soaked naked in the hot springs tubs, alternating with cooling jumps into the frigid river.

As if the trip so far was not stimulating enough, we sat in the sauna together, rubbed oil onto each other and massaged each other

without it being sexual. The Kundalini was definitely rising, on more levels than just spanning the height of the California state. Knowing that we needed to preserve our energy to hike the next morning, we cleaned up and left the hot springs spa around 10 PM. We drove to about 4,000 feet and parked Bobby's Bronco under the stars to sleep. That's what we did, sleep.

The next morning, after Bobby cracked and swallowed three raw eggs, we climbed Mount Shasta from 6,500 feet to 13,000 feet elevation. We weren't really prepared for temperature changes or a need to hike through snow. We simply put on our hiking boots and off we went. The weather was sunny and warm, the scenery was gorgeous, and we both had great energy to ascend this sacred mountain.

Towards the top, we were no longer following a clear pathway. We found ourselves climbing over rock piles, maneuvering over tree-lined cliff edges, and sensing our way up without a map or compass. Soon enough we hit snow. As we weren't dressed for colder weather or have crampons to assist climbing through the snow and ice at higher elevations, we simply drudged onward as best that we could.

Somehow, and I will never really know how, we did it. Near the top (maybe 5-600 feet from the top), we found a small clearing where we both laid down on our backs as our first rest stop since we began. I laid down with the back of my head on Bobby's chest. We were both speechless from the majestic peace and unexplainable wonder of nature. We joked about wishing to experience St. Germain, and I mentioned craving my mother's Italian sauce. That is all that either of us remember. We both fell deep, deep asleep. According to Guy Ballard, a mining engineer, while hiking on Mount Shasta in 1930, he encountered a man who introduced himself as Comte de Saint Germain, a historical

18th-century alchemist and known as one of the greatest philosophers who ever lived.

Saint Germain is said to have started Ballard on the path to discovering the teachings that would become the "I AM" Activity religious movement. The term "I AM" is a reference to the ancient Sanskrit mantra "So Ham", meaning "I Am that I Am." The movement teaches that the omnipotent, omniscient and omnipresent creator God ('I AM') is in all of us as a spark from the Divine Flame, and that we can experience this presence, love, power and light through quiet contemplation and by repeating 'affirmations' and 'decrees'. By affirming something one desires, one may even cause it to happen.

Bobby and I both awoke at the exact same time, both describing a surreal, deep and healing sleep. We knew that we had better get going down the mountain since we were already losing daylight. Walking

down the shale rocks covered with ice and snow was particularly tricky while descending on foot, so Bobby had the idea of sliding down. At first it seemed a little dangerous, but I didn't really have other options to offer or choose from, so I followed suit. I was only wearing a pair of spandex "booty" shorts on my lower body, so I tied my long sleeve shirt around my waist and held it to my thighs to save my backside from freezing. We slid about one hundred feet at a time, and honestly it was a lot of fun. This was nature's amusement park. We just had to be mindful of sharp rocks or snow-covered pitfalls, using our feet to clear and pave the way.

When we reached Bobby's Bronco at 6,500 feet, we were both exhilarated and exhausted. We changed out of our wet clothes and slowly made our way into town for an Italian dinner celebration. Since we were both so supercharged with nature's energy, we could barely engage in conversation, even though we couldn't keep the smiles off of our faces. We enjoyed our meal peacefully and nourished our bodies after the rigorous and physically demanding day.

The entire trip I pondered to myself if it would be an enlightening, higher tantric experience to have sex with Bobby after our journey so far. Our energy together was great, our experiences had been surreal and harmonious, and here we were at the majestic summit of Mt. Shasta. We slept in the back of his Bronco again that night, at the 6,500 feet trail base, looking up at the luminous stars. I couldn't sleep because my body was literally pulsing – every part of me was vibrantly alive. I could feel Bobby's body pulsing next to me, too. I heard Bobby turn towards me. He asked if I was awake. I knew that this was the moment, and for whatever reason, I just couldn't do it. I pretended to be

deep asleep, letting the surging ascension opportunity dissipate at the chaste crown chakra of Kali-fornia, or quite possibly maintaining the purity of this beautiful moment together.

Chapter 6

"If the blind put their hands in God's, they find their way more surely than those who see but have not faith or purpose." -Helen Keller

Medjugorie, Croatia – Believing is Seeing

A few months before my thirtieth birthday, my mother called to invite me back to Medjugorie, Croatia as her birthday gift to me. Medjugorie is a small village in Croatia that became well known throughout the world when six children claimed to have seen visions of the Virgin Mary beginning on June 24, 1981. I had visited Medjugorie when I was seventeen years old, during a trip that my mother had also organized for my brother and I, and it was eye opening on many dimensions at a critical time in my spiritual development.

My initial trip was one of the first times where I witnessed physically inexplicable occurrences. Even though I was raised with the Catholic religion, I have always been a staunch believer in science and perpetually sought to comprehend spirituality from a realistic perspective. I wanted to understand the unseen phenomenon.

As a young teenager visiting this rural, hillside village, I witnessed lights spiraling around the room or church during the time of the apparitions. These appearances were consistently at 6:40 PM, although the Virgin Mary also appeared to these children at other times. These lights lacked scientific explanation. Trust me, I ran around the church – inside and out – looking for ways to explain these lights that disappeared after the apparitions: *Was there an open window? A reflection on metal? A projector? Anything?* Even stranger, no one else around me witnessed the same things that I had, when I asked them or pointed them out.

I saw with my own eyes the image of the Virgin Mary appearing in numerous photographs of those visiting, taken at different times and destinations throughout the village. One of my favorite photographs in

this nature is of my mother, with the Virgin's image in both of her eyes. At a young age, I made assessments to the path captured in these photographs – this image always "flew" in a helix-like spiral. At that moment, I realized that energy does not travel in a circle or as a one-dimensional wave rising with a crest and dipping into a trough, but in a perpetually all dimensional spirals. Wavelengths do not travel up and down, but appear so when we capture the circular heights of the diameter's width. It made complete sense, even down to our DNA coding.

Over the last few years, I was delving deeply into yoga. I no longer attended church or considered myself Catholic anymore, but I was still very devoted to my reverence for God, Jesus, and Mary – but in all forms. I felt the Holy Spirit around me, but I now considered myself "Spiritual," since I also felt the same forces in other forms, philosophies, archetypes, and religions. I responded to my mother that I would love to go back to Medjugorie, as it is one of the most beautiful and reverent places I had ever visited. However, I asked her not to expect me to become Catholic again. Although I know that she clung to that hope, she agreed in spite of it.

The week prior to our Medjugorie trip, I was leading a surf & yoga retreat in Costa Rica. Once I landed back in Los Angeles from Costa Rica, I would board another flight to Buffalo, NY twelve hours later. There I would meet my mother for our trip to Croatia. On the last day of my trip in Costa Rica, I was surfing with a group of people from my retreat. As I paddled for a wave, so did another guy, Michael, who was to my left. He was newer to surfing. We both jumped on the approaching wave, a few seconds apart. I landed my jump, but as

Michael jumped onto his short fiberglass board, he slipped backwards, propelling the pointed tip of his board right into the left side of my upper back.

I felt the impact and fell backwards off of my board. Immediately I felt a searing pain on the left side of my upper back radiating to the left side of my head. I came up out of the water with both of my arms over my head and my eyes closed. Several friends swam over to make sure that I was OK. I assured everyone that I was fine, although inside I was a little worried about what I was feeling; I just didn't want the attention. Someone else retrieved my board while I swam out of the water and sat down on the beach to rest.

That night, I woke up around 2 AM with pain radiating from my left eye. I realized that I could only close my right eye, but not my left, and I had fluid running down my face. I ran into the bathroom. As I looked into the mirror, I screamed out of shock at what I saw. My left eye was the size of a golf ball, and it was oozing fluid down my cheek. I quietly walked downstairs to get ice out of the freezer, not wanting to wake anyone else up. I sat on the outside patio with a pack of ice over my eye, looking out at the stars and listening to the soothing sound of the ocean's waves. Then I starting to really freak out.

It was now about 3 AM and I couldn't fall back asleep. I had a 9 AM scheduled flight to the capital of Costa Rica, San Jose, from Tamarindo. Once in San Jose my flight departed at 3 PM back to Los Angeles, CA. As I mentioned, I then had a flight the following evening after landing in LA, heading to Buffalo, NY to meet my mother before our trip to Medjugorie.

When I arrived in San Jose, my eye was even more swollen and I couldn't stop the fluid from draining down my face. The flight staff approached me while I was seated at the boarding gate. They told me that I could not fly with my condition. I will admit that I did look like an ogre of some medieval nature, so I could understand their concern. However, I begged them to please let me on my flight, telling them that I needed to get medical attention back in the US. After about an hour of begging several supervisors, I was approved to fly if I signed a consent waiver disclaiming any liability to the airline. I agreed, signed, and boarded my flight.

When I arrived in Los Angeles, I immediately took a cab to the Emergency Room at St. John's Hospital in Santa Monica. I arrived there a few minutes before midnight, and did not leave until 3 AM, after receiving my diagnosis. The doctor informed me that I had traumatic optic neuropathy, from being struck in my upper back with such force. She suggested that I may have landed by striking my face on the tip of my own board. I had extreme inflammation which then became susceptible to the bacteria in the ocean water as I went under with my eyes open. It was a jackpot of a bad problem. The doctor told me that she could see the bacteria literally drilling a hole in my line of vision, and that I may need surgery in order to keep my vision intact. She wrote a prescription for antibiotic and anti-inflammatory drops that I had to alternate every hour.

I then told the doctor that I had plans to fly to Croatia that same night. She immediately shook her head and said, "The pressure from one flight alone may very likely leave you blind in this eye. You need to rest." I told her that I would be visiting a village where people flock

worldwide for miraculous healing; that the Virgin Mary appeared to six children there. As you can imagine, she looked at me as though I was admissibly crazy and left me with her final words, "You should absolutely not fly until the inflammation has gone down in your eye and you are cleared, otherwise you will be blind in one eye."

I did not sleep a wink that night (pun intended), and I tossed and turned uncomfortably while trying to decide if I could really walk the talk of my faith. *Did I believe that I would be healed? Could I take such a leap of faith of mind over matter, even if it risked being able to see with both eyes for the rest of my life?* I called my mother at 5:30 AM, telling her what had happened, and what the extreme risks were if I were to fly that day.

Let me tell you a little bit about my mother. She is the most devout Catholic that I know, and sprinkled with a spirituality that transcends her religious beliefs. It is in the way she moves. She has the "Goddess gene"; pure rhythm and soul, which is the wind beneath both her and my wings. Having been deeply involved in her religious communities for many years, she is personally connected to one of the Virgin Mary visionaries in Medjugorie. Ivan travels to the U.S. on speaking tours more than the other visionaries. He has even stayed at our home outside Buffalo, NY while lecturing at conferences and events in the Western New York area. Of course, I could feel strongly that my mother wanted me to go, regardless of what the doctor had said. She believed that I would be healed.

You have to know me by now. I. Decided. To. Go. It wasn't just one flight that I had to overcome. I flew from LA to Detroit, and from Detroit to Buffalo. From there we flew to Washington, DC to catch a flight to Frankfurt, Germany. By the time we landed in Frankfurt, I was

in so much pain that I could not even open my right eye, because even the little bit of light that crept in with my right eye opened exasperated the pain in my swollen left eye. The swelling had increased, and I was in a state of sheer panic. We had a several hours layover in Frankfurt, and my mother was guiding me through the airport, like a blind person.

It was then that I had my "Saul moment." I was filled with so much sheer fear and the further along I went on this journey, the more I feared losing my eyesight. My mother enjoys telling the next part of this story, reminding me of my dark, dark moment. I stopped in my tracks. I have no idea where in the airport that we were – a terminal, restaurant, boarding gate – because I could not see. I pulled my arm away from my mother who was still guiding me. I then screamed out in anguish while crying, "You and your f-ing religion! I am going to be blind for the rest of my life!!" To my mother's credit, that didn't waiver her faith one bit. It actually strengthened it. She simply waited for me to exhaust myself, suggested that I calm down, and that "getting upset was not going to help." We needed to pray, she said. That wasn't what I wanted to hear and I continued sobbing in discomfort and fear.

From Frankfurt, we had one more flight; to Split, Croatia. From Split we boarded a three-hour, extremely bumpy bus ride to the mountain village of Medjugorie, arriving around 9 PM. Now remember, because of my mother's deep involvement in her religious communities, we were staying at the home of one of the Virgin Mary visionaries, not a hotel. Ivan offered several guest rooms to pilgrims. I had met him before on several occasions, but when I stepped off that bus, he must have thought a demon child had arrived. I had not slept in three days. I was exhausted, afraid, disheveled, and angry.

Ivan led my mother and me to our room, where we each had a twin sized bed. Once there, I laid down on my bed and he placed his hands over my eyes. As he was praying over me, I finally fell asleep, as that is all that I remember from the night we arrived. Not only did I fall asleep, I slept through the night without waking in any pain or discomfort. When I awoke the next morning, my eye was still swollen and draining, but not nearly as much as it had the last few days. More so, I was still without discomfort. This greatly shifted my agitated attitude back to a state of trust and humble reverence.

Even after fifteen years since the first apparition, Ivan still receives daily visits from the Virgin Mary, at 6:40 PM every evening. We gathered in his private home chapel, praying around him as he received her visits each night. We watched as he dropped into a state of sheer ecstasy while communicating with Her for several minutes. Afterwards it took him several more minutes to acclimate back to our dimension, where he would relay her messages.

I am embarrassed to admit that even with all of the extraordinary experiences that I have had in my life up to date, I was still skeptical

whether or not Ivan was actually still seeing the Blessed Mother every night. There is absolutely no doubt in mind that the six children (including Ivan) witnessed these miraculous apparitions when they were younger, *but was Ivan really still seeing her still today?* I couldn't imagine that he would lie, but I am skeptical by nature. While everyone else was in a reverent state of prayer, I kept my eyes open, watching for proof to see if the apparitions were real or not. But, if we don't turn the lights on inside, we won't have the capability to see. I was in a dark space at that time, given my circumstances leading to this visit, and I projected that blindness onto my experience.

By the end of our weeklong visit, my spirit and mood brightened dramatically, and as you probably have already guessed, the inflammation in my eye was now completely gone, and without any loss of vision. I was and still am incredibly grateful and joyous of this outcome. On the last day of our trip, which was a Sunday, we were all dressed for Sunday mass. I was wearing a long, flowing, peasant-like dress, similar to the local style of dress. My naturally dark hair was very long at that time. It landed just below my lower back.

The sun was setting, and my entire group (without Ivan) was gathered on the front porch of the house, saying our goodbyes to each other and sharing gifts since we would all be departing home to different cities. There was a man from Boston in our group who gave me a bundle of light-colored wooden rosaries, held together with a rubber band in the middle. Being in a very light and playful mood, I placed the bundle of rosaries on top of my head, so that each end draped on the right and left side. It looked like my hair was beaded,

and I danced around waving my head while we all shared a good laugh.

As the sun had now set, the glow of the moonlight was shining brightly. With the beads still on my head, I made my way back, alone, to our guest room. As I turned the corner of the main house, my dress and hair flowed gracefully with my turn. I saw Ivan sitting on the edge of the walkway to the guesthouse with his housekeeper. They were talking about one foot away from each other.

The next moments felt as though they happened in slow motion, and even today they still run through my mind with that same slow-motion memory. Ivan looked up at me as I turned the corner. In one split second his eyes widened, he fell to his knees, and he spoke one single word expressing both surprise and delight. "Gospa!"

I froze in place, completely speechless. Very quickly Ivan realized that it was me, Alanna, and not a surprise visit from the Virgin Mary, or "Gospa" as she is called in Medjugorie. The peasant dress, the long dark hair, and the moonlight striking the wooden beads on my head may have appeared more like an aura or crown. I can only assume this, as Ivan and I have never spoken about the incident. Ivan quickly apologized to me, and I continued walking up to my guest room.

When I entered my room, I immediately sat on my bed to catch my breath. I was trembling. In that one mistaken moment, not only was I shown clear proof that Ivan does in fact see the Virgin Mary, just as you and I see each other in this physical dimension, but I was actually mistaken for her, even if it was only from a shadowed periphery outlined by the moon.

My mother and I flew back to Buffalo, without incident or discomfort. I stayed in Buffalo for a few days to visit with my family before flying back home to Los Angeles. While in Buffalo, I saw an ophthalmologist for another eye exam. I had requested my test results and doctor's notes to be sent from St. John's ER in Santa Monica. The eye doctor simply could not believe that my eye had healed, and so quickly at that, especially given all of the flying and traveling we did in the last week.

Here's where this story gets even more remarkably beautiful. Since I was a teenager, I had worn glasses or contact lenses for near-sighted vision. I have not worn contact lens or glasses since that trip to Croatia. I keep a pair of glasses in my car for driving at night, just for precaution, but each time I renew my driver's license, I pass the eye test without corrective lens. Seeing surely is believing, but sometimes when our sight is taken away it becomes clearer that believing is truly seeing.

Chapter 7

"Wakan Tanka, Great Mystery, teach me how to trust my heart, my mind, my intuition, my inner knowing, the senses of my body, the blessings of my Spirit." —Lakota prayer

Return to Mount Shasta

In June of the following year, I organized another "Goddess" retreat. I decided to bring a group to Mount Shasta. There were thirteen women signed up for the weeklong retreat. I rented a van in Los Angeles, and I drove ten of the women from our group nine hours north to Mount Shasta. The other three women were meeting us there at the lodge, where we would be staying. My dear friend Kelly, drove in the van with us. I had met Kelly several years earlier while working for a family as their yoga teacher. She was their nanny, and we became fast friends.

As we were driving, the conversations shifted frequently from excitement and anticipation for the retreat, to more whimsical topics, as well as everyday conversations about life, love, and food. About halfway into our road trip, Kelly had an idea. "We should all pick Native American animal totems before the sweat lodge tomorrow," she said. Everyone agreed. Kelly decided on *Dragonfly*, which seemed appropriate for her. At first, I thought to call myself *Buffalo*, as that is the city where I am from, and it has great Native American ties, but the image of the buffalo felt too harsh, I thought. I picked *Hummingbird*, based on what Shaman Kuyichi had told me during my trip to Machu Picchu in 2002.

Personally, I was working through heartache at that time in my life, and the women in my van were asking me about this somewhat dramatic and scandalous situation. I was trying to get over Rick, the fellow yoga instructor who I had an intense, psychically passionate relationship with. I had only been teaching yoga for about one year, and my classes were becoming very popular.

During this time, I received a call from an infomercial company wanting me to audition for a yoga infomercial that they were producing. The producer on their staff had recently taken my class and thought that I might be a better fit for the job than the yoga instructor they had contracted. Additionally, that instructor was asking for more compensation, and the producers were not happy about his attitude and demands.

When they informed me of who this yoga instructor was, I acknowledged that I had heard of him (not good things), but that I had never taken his class. Ironically enough, the owner of the yoga studio

where I was working at that time, Maha Yoga, specifically disdained this instructor and had told me never to take his class. He had a consistent reputation of being aggressive, selfish, greedy, and very egotistical. Based on these things, I could understand why the producers were growing frustrated with his pressing requests for more money.

To shorten a long story, the producers thought that we could co-host the infomercial, expressing the idea that we would complement each other very well. They suggested that I take his class, and to let them know my thoughts afterwards. I agreed, and planned to go to his class the very next morning.

Now, I had only had a "love at first sight" moment twice before in my life. This one surely topped the others. It was quite obviously mutual. From the moment that I walked into the yoga studio, Rick mesmerized me, and I him. While our eyes were locked he walked backwards holding our gaze among sixty other students who were also preparing for class. We couldn't take our eyes off of each other.

During class, he circled my mat like a shark, adjusting me sensually in nearly every pose. The words he chose to speak were clearly directed towards me, and I was soaking up every moment and ounce of attention. After class, he charmingly introduced himself to me, and complimented my "very beautiful yoga practice." I thanked him, nervously, and quickly left. I was overwhelmed with his intense focus on me, and honestly felt shy even though these intense feelings were mutual. Ironically, I exhaled for the first time in the last hour when I reached the sidewalk downstairs from the studio.

After leaving class, I called the production company and gracefully declined their offer. I turned down a massive opportunity to co-host an eighty-three million-dollar yoga infomercial because I felt a "soul mate love" connection through a non-verbal, energetic fashion that frankly speaking, only devalued me as less worthy and uncertain. I started to become addicted to the attention Rick gave me in class. Other students commented on his behaviors toward me, some even asking me where I was going to place my mat because they loved watching how he adjusted me. Once he maneuvered my body into full King Pigeon pose, and from behind me while my hands were holding my foot, kissed the back of my neck. I was blind to see how inappropriate his actions were becoming, and somehow the more intense that he became, the shyer and more awkward I became. Don't get me wrong, I liked it, but I was not going to be "that" girl. Plus, I heard he had a girlfriend.

After a few weeks of this adrenalin pumping attraction, Rick asked me if I would be an "extra" in an infomercial that he was shooting. He said that he needed a handful of people with great form, and that he would pay me $300 plus some pots and pans offered from the production company. I probably should have mentioned at that time that I was also an instructor, and that I came to be in his class because I was also being auditioned to co-host the very job he spoke about. But I didn't. I simply, meekly said, "Yes."

When I arrived for the filming of Rick's infomercial, I was immediately greeting by the producers with familiarity and surprise. They expressed their shock as to why I was there. They were even more baffled to learn that I was going to be an extra, at that. When Rick saw the communication which I was having with the producers, and the

obvious familiarity between us, he approached us to see what was happening.

One of the producers lightheartedly opened the can of worms, sharing how they had considered me as Rick's co-host. Rick glared at me, and he glared at me hard. This was the first of many showings of a very aggressive and threatened man. I explained to him that I was also a yoga instructor. He asked me where I taught, and I told him. He literally flipped out, irrationally overcome with anger. He swore at me, using the "f" word about fifteen times in one minute. My heart sank to my feet, and I felt confused and afraid.

Knowing that he had a job to do, he self-corrected, pulled himself together and continued preparing for the shoot. I stayed for a few shots, but unable to recover from his outburst, I left before it was finished. Our "relationship" (if you can call it that) was purely energetic, and he was definitely the initiator. We were both highly intuitive, sensitive beings which created a highly energetic connection. It was too difficult to explain to people who had not witnessed us together, but those who saw us in class had a clear sense of the something that was going on. Thankfully, nothing further happened between us, and I learned a huge lesson for having thrown away such a great opportunity for myself because I was smitten by his ego.

I returned back to the present moment, driving my group of Kali-fornia Goddesses to Mt Shasta. The conversation in our van shifted again from Rick to my upcoming yoga retreat to India the following October, which I was greatly looking forward to for many reasons. It would be my birthday while we were there, and my birthday fell on a solar eclipse, to boot. Navaratri, a nine-day Hindu festival dedicated to

the Goddess Durga, would also be happening during our retreat. Additionally, I was looking forward to getting away so that I could detach and heal completely from the increasingly toxic situation with Rick.

I was in the beginning stages of organizing this incredible trip, and I already had five women confirmed for the excursion. I had recently discovered that I was born on the Hindu "Day of Victory," which is the tenth day that follows the nine-day Navaratri celebrations honoring Durga for her victory over evil. What an incredible and auspicious jackpot that the day of my birth lands on one of the most well-known and recognized Catholic miracles related to a feminine deity, as well as one of the most auspicious days in Hinduism devoted to the warrior Goddess Durga.

We arrived in Mount Shasta around 7 PM that evening. We settled in our cabins, enjoyed our first juice, and went to sleep surrounded by majestic trees and the sounds of the Park Creek next to our lodging. The next morning, we juiced again, practiced yoga, and departed for our local hike at Black Butte. Upon return, we juiced again, soaked in the mineral hot springs and prepared for our evening sweat lodge with our lodge leader, Walking Eagle, a tribal elder of the Karuk Tribe.

A sweat lodge is a traditional and spiritual practice of cleansing the body, mind and spirit. Attendees sit in a circle inside a hut covered with material and tarps. The lodge is typically dome-shaped and made with natural materials. Rocks are placed in a fire to heat for many hours prior to the ceremony. Inside the lodge, the hot rocks are carefully placed in the center of the circle, and the leader pours water onto the

rocks while performing the ceremonial steam baths and prayer. Through the sweat ceremony, toxins are eliminated from the physical body, while chanting, prayers of gratitude, and reflection increase one's connection to nature.

During our ceremony, while Walking Eagle was chanting and pouring water on the heated rocks, I felt a massive sense of stillness and quiet within me. I was riveted by how this feeling overrode everything else happening around me. I then heard a clear, deep voice from within. With all other sounds greatly dimmed, this voice stood out, stating that I had to go to India alone, instead of leading a retreat with other women. I felt a sense of confusion and anxiety mixed with fear.

At the same time Kelly, or Dragonfly, who was seated to my left turned to me and placed her hand on my upper left arm. As I turned to her in response, she said, "You're White Buffalo." That statement echoed in my mind and her face seemed to freeze in time. I did not know what that meant, or that there were deeper meanings (that I would later discover), but I loved the sound of it, the purity and strength that it implied, and I received that beautiful gift from Dragonfly. I was White Buffalo. Walking Eagle overheard Kelly. He took a ladle full of water, threw it onto the hot rocks, creating a huge burst of steam inside the lodge. He said, "Let us also give thanks to the White Buffalo Woman." I thought that he was talking about me (I would later learn otherwise), and being a little overwhelmed and embarrassed, I closed my eyes to meditate in a humble state of gratitude for the remainder of the lodge ceremony.

After the sweat lodge was finished, I exited the lodge and began walking back to our cabins. My friend Margo ran up to me, saying that I

looked distraught. She asked me if there was something wrong. I told her about the voice that I felt and what I heard. I told her that I was scared to go to India alone, and that I was confused. Margo, a private investigator by trade, knew me better than most people in my life. She knew that I consciously honored my feelings, listened to symbolism and synchronicity, and lived true to my spirit. She asked me, "What are you going to do?" Although I was still shaken, we both knew the answer. "I have to cancel the retreat to India," I said.

White Buffalo Calf Woman

I couldn't stop thinking about "White Buffalo," or seeing Kelly's face when she gave me that title with such conviction. Upon returning home from the Shasta Goddess retreat, I went online and Googled the words "white buffalo." I nearly fell out of my seat when the search results filled my computer screen. I was simply breathless. First of all, having been born in Buffalo, NY, and secondly to read about the following Native American legend centered on the apparition of a holy woman 2000 years ago called *The White Buffalo Calf Woman*, I was filled with wonder and delightful anxiety.

To Native Americans, the Bison or American Buffalo has always been a symbol of sacred life and abundance, and the birth of a white buffalo in particular is a symbol of rebirth and world harmony. This importance and symbolism was created from the following great legend:

One summer, the seven sacred council fires of the Lakota Sioux came together. The sun was strong and the people were starving and

without food. Two young men went out to hunt in the Black Hills of South Dakota in hopes of bringing game back to the camp. They searched everywhere but could find nothing. Seeing a high hill, they decided to climb it in order to look over the countryside for better perspective. Halfway up, they saw something coming toward them from far off, but the figure was floating instead of walking. From this they knew that the person was *wakan*, holy.

A beautiful young woman dressed in white appeared to the warriors. She wore a wonderful white buckskin outfit. It was embroidered with sacred and marvelous designs of porcupine quill, in radiant colors no ordinary woman could have made. This *wakan* stranger was Ptesan-Wi, White Buffalo Calf Woman. In her hands, she carried a large bundle and a fan of sage leaves. She wore her hair loose except for a strand at the left side, which was tied up with buffalo fur. Her eyes shone dark and sparkling, with great power in them.

The two young men were in awe. One bowed in reverence, but the other desired her, stretching out his hand to touch her. This woman was *Lila wakan*, very sacred, and could not be treated with such disrespect. Lightning instantly struck the brash young man, burning him leaving only a small heap of blackened bones.

To the other scout who had behaved rightly, the White Buffalo Calf Woman said: "Good things I am bringing, something holy to your nation. A message I carry for your people from the buffalo nation. Go back to the camp and tell the people to prepare for my arrival. Tell your chief to put up a medicine lodge with twenty-four poles. Let it be made holy for my coming."

This holy woman presented the Lakota people with the sacred pipe, which showed how all things were connected. She taught the Lakota people the mysteries of the earth. She taught them to pray and follow the proper path while on earth. Before the woman left the tribe, she promised that she would return when a white buffalo was born. She then rolled upon the earth four times, changing color each time. The first time, she turned into a black buffalo; the second into a brown one; the third into a red one; and finally, the fourth time she rolled over, she turned into a white buffalo calf. Then she disappeared. Almost at the same time as her leaving, great herds of buffalo could be seen surrounding the camps. It is said that after that day, the Lakota honored their pipe, and buffalo were plentiful.

This story of the White Buffalo Calf Woman has immense importance to the Lakota and many other tribes. When Roman Catholic missionaries first came among the Lakota, their stories of the Virgin Mary and Jesus became associated with the legend of White Buffalo Calf Woman. This melding of identifying Mary with Ptesan Wi continues among Lakota Christians to this day. The Native Americans see the birth of a white buffalo calf as the most significant of prophetic signs.

"The arrival of the white buffalo is like the second coming of Christ," says Floyd Hand Looks For Buffalo, an Oglala Medicine Man from Pine Ridge, South Dakota. "It will bring about purity of mind, body, and spirit, and unify all nations — black, red, yellow, and white."

I spent hours reading many versions of this White Buffalo Calf Woman myth. I also stumbled upon Egyptian writings also about a Goddess and a White Buffalo, and wondered if they were somehow

related in origin. In Chapter 84 of the Egyptian Book of the Dead a passage reads: *A prophecy foretold that the birth of a white buffalo calf would be a sign that it would be near the time She would return to purify the world.*

I became intent on finding proof of a white buffalo, and the scientific realities of being albino, or if it was even possible. I read about a DNA-proven white buffalo named Miracle in Wisconsin, who died less than two months after I read about her. Unfortunately, I was unable to have visited Miracle. As I continued reading I discovered another DNA-proven white buffalo born in Flagstaff, Arizona. Her name was Miracle Moon. With only under ten domestic reports of a white buffalo in the last three hundred years, I felt a strong desire to visit Flagstaff.

I drove to Flagstaff with my friend Margo, my private investigator friend who attended the Shasta Goddess Retreat. We spent the day at Spirit Mountain Ranch, learning about the white buffalo and visiting Miracle Moon. I keep a clump of her white hair in a special box of spiritual knick-knacks on my altar at home. After our time in Flagstaff we explored the many natural vortexes and new age communities in Sedona, which is only thirty miles away. My dreams are always more lucid in Sedona, and I felt a connection to Machu Picchu in regards to the magnetic mineral content in the earth.

The birth of a white buffalo is said to be the fulfillment of age-old legends. It's a one in sixty-million chance that a pure breed buffalo will be born white. And an even smaller chance that its offspring will also be white. However, a couple near Flagstaff can now say they have a matched set. When she was three years old, Miracle Moon had her first baby, another white buffalo. The owners, Jim and Dena, named their new white buffalo Rainbow Spirit. The birth is significant to many

because of the Native American myth that tells of a young woman who taught them how to use the buffalo for survival. When she left the people, she turned into a white buffalo & promised to return. When she returned it would be a time of chaos & disaster in the world. It would also be a time for all races to come together in peace, balance, & harmony, and bring healing to the world.

I didn't understand what all of these synchronicities meant, and they often stirred anxiety within me as I struggled to unravel the complex formula for both personal and universal comprehension. Over time a grander sense of realization and revelation settled in my mind, eased by the same themes repeating themselves over and over with slight variances. Our collective consciousness is far more centralized and focused than we may think.

In the meantime, I was greatly enjoying the adventures and realizations, struggling to understand my personal interpretation and meaning of them, while eternally and deeply fascinated by the myths and stories connected by these common denominators. Through these discoveries, my unique self-reflection, purpose and revelations become gradually known. They were slow enough to digest, and always revealed at the perfect divine time.

Chapter 8

"India is not the earth, rivers and mountains of this land, neither is it a collective name for the inhabitants of this country. India is a living being, as much living as, say, Shiva. India is a goddess. If she likes, she can manifest in human form." —Sri Aurobindo

Mother India

After returning home from Sedona, I began to prepare for my trip to India. Having recently discovered that my birthday was related to the Hindu Goddess Durga, I began researching a great amount of Hindu mythology. I would be celebrating Navaratri during my trip, the nine-day celebration to Mother Goddess and the victory of light over evil.

The Myth of Goddess Durga

According to the narrative from the Devi Mahatmya, the form of Durga was created as a warrior goddess to manifest on Earth with the mission of conquering a buffalo demon named Mahisha (*mahisha* means *buffalo*). *Oh boy*, I thought, *more goddess / buffalo symbolism*. After intense prayers to Brahma, Mahisha received a boon, or protective blessing, that no man or god could ever defeat him. By virtue of this power, he became excessively greedy, abusing his sexual powers, invading the gods and creating havoc on earth. Mahisha defeated all of the gods including the Trinity themselves. He unleashed a reign of terror on earth, heaven, and the nether worlds.

The gods gathered to plan how to defeat him. The idea of sending a woman was raised, in order to pass around the boon protecting Mahisha. The Trinity agreed, and they each contributed to the creation of the goddess Durga. Her form was blindingly beautiful with three lotus-like eyes and eight powerful hands. She was referred to as the Maha Maya because she was the Supreme Illusion.

Each god also offered his own most powerful weapons. The Himalayas gifted her a fierce white-gold lion named Vijay for her to ride. When she first manifested on earth, she appeared in the form of Chamunda. Mahisha grew initially desirous of her and tried to marry her. He chased her to Northern India where she hid in a cave for nine months. There in that cave of Self-realization, she grew to understand who she was. She then transformed into Durga, fully knowing of her purpose. She chased Mahisha back down the countryside to Mysore and finally on the tenth day of a waxing moon, goddess Durga killed Mahisha with her trident on Chamundi Hill.

The word *Shakti*, meaning strength, reflects the warrior aspect of the goddess. I have always felt a strong affinity toward this myth, even before learning of being born on this tenth day of Victory, but now knowing the finer details and mentions of *buffalo* and *Chamundi* (which was similar enough to the Mayan Princess Chamu mentioned back at Machu Picchu), I dove into understanding the deeper meanings and symbolic intricacies related to my own life's purpose.

Additionally, and personally, I have practiced Ashtanga Yoga, which is central to Mysore, India and the victorious location for this defeat to occur. Astrologically, I have *Leo rising*, symbolically riding a lion at the hour of my birth, and my mother (the vehicle for my manifestation and birth) is a Leo. My family has a strong affinity for the word *victory* as we descend from King Victor Emmanuele of Italy, and I was baptized at Our Lady of Victory basilica in Buffalo, NY.

I started feeling a little overwhelmed. There is a fine balance of seeing ourselves and our synchronicities while also understanding universal one-ness of all and not falling prey to narcissistic egocentric beliefs. We are all connected, and we all have divinely poetic reflections that transcend time and space, together. I have simply allowed my life to reveal itself to a degree that I rarely see others do. Most people want to *manifest* and their excessively desirous hungers deny these divine gifts from being revealed in nature's time and perfect manner.

While researching where to go in India, I emailed an American author who wrote about Navaratri events. I asked him for suggestions on where I should visit. He told me about a present-day saint named Karunamayi, who lives at her ashram in the northeast part of India. He told me that she is one of two Indian saints who are believed to be

manifest in the form of The Divine Mother (Amma, the Hugging Saint, is the other – who is also a Libra). He told me that Karunamayi was also was born on the Day of Victory, and upon hearing this, I knew that her ashram was the perfect place to celebrate my birthday and Navaratri.

I applied online to visit and stay at her ashram for the ten-day celebration. A few days later I received a reply that my application was accepted. I followed the subsequent requirements: I mailed my deposit, obtained my visitor's visa, and booked my airline ticket to arrive in Chennai. Chennai is a city on the east coast of India, and from there I would travel north to the remote ashram. Otherwise, I would have chosen to fly into Bangalore, closer to Mysore where I could practice Ashtanga Yoga with my teacher, Pattabhi Jois. I booked Mysore as my departure city, planning to spend time at Guruji's yoga school.

At least one month went by, and I felt confident that the booking details for my trip were set. That is, until two weeks before my departure. I received an email from Karunamayi's ashram. I was informed that there was no more room to accommodate me, and that my reservation had been cancelled. I was assured that my deposit would be mailed back to me, unless I chose to donate it to the ashram. As you can imagine, I was completely disappointed and distraught.

With less than two weeks to prepare a solo, month-long excursion through India, I sat down with my trusted trip adviser, Google. I searched online for an "ashram near Chennai." A site appeared in the search results that included the following words in the description that caught my eye: *If it is your birthday while you are here, you may meditate in the saint's bedroom.* I lifted my eyebrows. *Whoa. It is going to be my birthday while I am there,* I thought. I clicked the link, which led

to the Sri Aurobindo ashram site. I had never heard of this saint before, but my faith and excitement were renewed. I emailed the contact link, asking if they had a room available for me from October 12-17. The magic of this trip, in particular, is the fact that I did not know prior details, and that I was forced to embrace uncertainty, spontaneity, and synchronicity. Even better was to be pleasantly surprised at how details came together so absolutely perfectly, far greater than I could have forced or planned. Isn't that a major theme of life? This upcoming trip would become living proof to me, in the least.

The next day, I received a reply from a man named Vijay (meaning "victory" in Sanskrit, and the name of Durga's lion). This was a very good sign. He informed me that Aurobindo's ashram did have a room for me, and that he would happily book the dates I requested. In addition, he offered to send a driver to pick me up at the Chennai airport to be sure that I arrived safely to the ashram. Things were really picking up! I was ecstatic to hear this great news. This positive reinforcement to embracing uncertainty led me to the decision that *I would say 'yes' to whatever comes my way. I would be open, accept, and say 'yes'.*

I committed to arrive at Sri Aurobindo's ashram to begin my Indian journey, and finishing my trip in Mysore at an Ayurvedic center that I had previously booked when I thought to be staying at Karunamayi's ashram. Everything in between would reveal itself, I concluded. I would listen as to where to go, in each moment. My only rules were to trust and to say "yes." Just to be honest, this was partly due to not wanting to research and arrange a new game plan of this trip, or risk disappointment if things didn't pan out as smoothly as my

email to Vijay. Regardless, my experience in India, October 2004, is still one of the most extraordinary, spectacular, mind-expanding experiences of my entire life, and I planned little to none of it.

"The Mother"

The next day, feeling completely settled and at peace about my upcoming trip, I decided to clean out a purse that I literally had not touched in two years. It had been hooked on the door handle of my closet, unused, unopened for the entire two years. As I began cleaning the purse, I came across a small pamphlet titled "The Mother." I recalled how my friend Hank had given this to me two years ago when we worked together at a spa in Santa Monica. He had recently returned home from a trip to Thailand and thoughtfully gave me the pamphlet as a gift. I had never read or even opened the pamphlet, but I did appreciate his kind gesture very much.

For some reason, I looked more closely at the pamphlet on this day, while sitting on the edge of my bed. What I read literally overwhelmed me with amazement. The pamphlet was from Sri Aurobindo's ashram! *The very same ashram* that I had never heard of before two days earlier and would be visiting in less than two weeks. I felt a very *Twilight Zone* kind of a feeling, but little did I know that this was only beginning.

Getting into The Dharma Zone

As I already mentioned in Chapter 2, twelve years prior to my trip to India, I had traveled to Fatima, Portugal and had a sketchy incident with a Portuguese taxi driver. I couldn't shake the fear of taking a cab alone, late at night, for a two-hour drive down the east coast of India. It started weighing heavily on me, until I realized (or justified in my mind) that this upcoming experience was an opportunity to reverse the previous traumatic experience with a taxi driver. I felt that I had to go through it without fear or reaction to settle any sankaras, or emotional scars, in my subconscious mind and energies.

I did not pack much for my trip at all. I brought a hearty selection of anti-parasitic herbs, three tubs of royal jelly honey, six boxes of Greens Plus bars, apple cider vinegar, food grade hydrogen peroxide (this was before strict traveling restrictions limited what we carried on to a flight), a Sri Chakra Puja (offering to the Divine Mother), St. Philomena novena (this arrived in the mail from my Mother as I was walking out the door to go to the airport), my astrological chart, Mother Teresa prayer, small duffle bag of clothes and more anti-parasitic pills, concoctions, and essential oils.

The morning of my departure, I had a wheatgrass colonic, went to a Catholic mass, saw a priest for a private confession, practiced three hours of Ashtanga yoga, and sat in meditation for another hour. I was feeling incredibly pure, receptive, and present.

Arriving Chennai

I arrived at the Chennai Airport at 10:20 PM the evening of October 12, 2004. Since I did not have any checked baggage, I walked

outside to the arrival section. There were rows of drivers waiting for their assigned passengers. They all wore the same white starched linen uniforms and held up signs with the names of their passenger on them. I walked through the rows, looking for a sign with my name, but I did not see one. I waited ten minutes or so, and again walked through the rows for a second pass. Then a third. Nothing. I was now growing concerned about not seeing my anticipated driver, and at the possibility of having nowhere to stay in a strange city at a very late hour. Not to mention that we were approaching my birthday and a fabulous solar eclipse. I was hoping (and I was attached and expecting) to be settled in, experiencing a divinely auspicious moment somewhere meaningful, not sitting on my duffle bag crying because my driver hadn't arrived.

I looked through my papers and itineraries. I had printed a copy of Vijay's email, which had his phone number on it. I looked around for a public phone. As I stood up, I made another pass around the drivers. I made eye contact with a man whom I had seen several times during my previous rounds, but this time he held up a sign with my name on it. I waved to him, saying "Hey! Where have you been?!" He was a short Indian man, normal build, probably in his late twenties, with a thick black moustache. He spoke good English and replied that he had also seen me several times. We were both confused as to why we had not connected earlier, but relieved to have finally found each other and be on our way.

As we walked to his taxi, fear started creeping in. Here it was, a late night solo cab ride in a foreign country. I developed a defensive attitude towards my driver that did not welcome friendly chatter. I wasn't rude, simply not overly friendly. As exhausted as I was I

remained alert the entire two-hour drive down the coast to Pondicherry. If I started nodding off, I quickly shook myself to stay awake. The streets were incredibly dirty, with piles of loose garbage along the streets. In my OCD mind, I pictured a giant fire hose flooding down the streets, cleansing as we drove.

Arriving in Pondicherry

We arrived late at the ashram. It was a stormy night, sprinkled with thunder and lightning. As I stepped out of the taxi, I placed my duffle bag over my shoulder while digging into my wallet for cash. My driver rang the doorbell of the ashram, seeming to be familiar with the layout and protocol. I tipped him while we waited to be let in, and verbally thanked him. A thin Indian man answered the door. He welcomed me inside, leading me to the reception desk. There he asked me to fill out registration forms required for my stay at the ashram. I picked up a pen from the desk and began to fill out the forms.

As I neared the end of the last form, a line asked for the time of my arrival. Feeling that *Twilight Zone* feeling again, and what felt like slow motion, I looked up to my right to see the time on the wall clock. It was a large, traditional schoolhouse style clock, with a large face and pendulum below it. As my eyes locked on to the clock, the second hand clicked on the twelve, confirming that moment exactly as 1:30 AM. This was the exact time of my birth, and it was now officially my birthday! The thunder and lightning roared. *Wow. I can go home happy right now,* I thought, *this moment was worth the price of my entire trip so far!* After

finishing my check-in, I found my room, which had a beautiful view overlooking the Sea of Bengal.

In addition to my heightened state, resulting from trying to comprehend my experiences so far in this foreign land, the ocean reverently reflected the moon, filling my room with bright moonlight. The lightning was consistently intense, and the thunder was startling. I used the towels from the bathroom to place over my pillows and bed where I was laying, since I was dramatically afraid of being eaten by a parasite of some sort. Although I did not sleep, I rested my body while observing my thoughts for the remainder of the night.

Sri Aurobindo's Ashram

At 7:00 AM I arose from my bed to get ready. I then headed into town. Once outside, the streets were busy with beggars, worshippers, and merchants lining the streets. I walked directly to the actual ashram of Sri Aurobindo. I mean, let's get right to it. I was staying in one of the Ashram's guesthouses, which was similar to a bed and breakfast

accommodation. When I arrived at the entrance of the Ashram, a man asked for my passport before entering. I gave it to him and he looked it over. After a few moments, he looked up at me with a beaming smile and exclaimed excitingly, "Today is your birthday!" I smiled embarrassingly in agreement before he stepped to the side, picking up a garland of white flowers.

When he turned back to me, he placed the flowers around my neck. "You may meditate in Sri Aurobindo's bedroom today!" he exclaimed. He went on to advise me how to spend my time. He suggested that I meditate for a while on the grounds before returning back to him when I was ready to go upstairs to Aurobindo's private quarters, still kept intact as they were when he left his body.

Following his advice, I sat in front of a cement enclosure with dimensions about 11 feet by 5 feet, covered with flowers. This was clearly Sri Aurobindo's burial site. I watched devotees approach the cement block, bow, place their heads on top of it, and pray to themselves. Many left flowers, cards, and tokens as well. I was overcome with emotions trying to comprehend why I was there, at this special place in such a profound manner, to the exact welcoming hour of my birthday.

I felt a very strong, loving presence that brought me to tears. I sought to know more. After fifteen minutes or so meditating, I returned to the man at the front entrance who had welcomed me so wonderfully moments before. I told him that I was ready to be taken to Sri Aurobindo's bedroom to meditate.

Aurobindo's bedroom

This kind, jovial man escorted me into Aurobindo's apartment. In a familiar way, it reminded me of my grandmother's house while I was a young child. There were knick-knacks on every shelf and table, including brass statues of figurines resembling Hindu deities. There were large ivory elephant tusks attached to the wall, tasseled velvet lamp shades over the table lamps, and large portraits of official looking Indian men.

I was handed an envelope, candies and another flower before being guided to the bedroom. Once inside, I sat down on the floor in front of Aurobindo's bed, which was covered with a blue velvet throw. My guide then left me, and I was alone to sit. I opened the envelope to find a birthday card. This was really special. Inside the card was a quote from Aurobindo which read: *Your birthday is the most receptive time of your year. There is no coincidence that you are here.* I closed my eyes, feeling a surge of enormous peace overwhelm me. I had never felt energy like this before. It felt as though I was submerged in warm milk, with the ability to breathe while submerged. That is the only way that I have come close to describing this ecstatic state - or maybe like being in the womb again.

I felt an enormous amount of love both around me and within me. Tears of gratitude and joy were running down my face and I felt the palpable presence of this wise, loving man. With such a uniquely profound experience I couldn't stop wondering, *why am I here?*

After about thirty minutes more of meditation, I made my way out of Aurobindo's living quarters on my own. As soon as I exited the front door, I sat on the stairs outside of the apartment for at least another thirty minutes, catching my breath and trying to re-acclimate to

reality. I couldn't understand what was happening. When I again felt realigned with time and space, I walked downstairs to the ashram bookstore. I wanted to learn more about who this divine, multi-dimensional, ever-present man was. This surely was no coincidence.

The woman working at the bookstore was American, surprisingly, and she was incredibly peaceful and kind. She had a medium, healthy build with brownish blonde hair, and her sparkling blue eyes magnified her sincere kindness. She wore a casual Indian sari. I told her that I knew nothing about Sri Aurobindo, but that I wanted to learn more. She gave me a brief summation that perked my interest even greater, adding more weight to the lack of coincidence.

She told me that Aurobindo was an Indian attorney who became educated in Great Britain. He was also an activist, politician, and writer. Upon returning to India, he became a leading public advocate for liberating India from Britain. She mentioned that he openly spoke of his struggles with power and spirituality, and felt that he had to make a conscious choice, ultimately choosing to leave "the world" to fully walk his spiritual path. He felt that he could achieve greater accomplishments in the spiritual realms of existence than he could fighting the physical world – as we know it – through legislation and activism. He was very aware that in doing so, he likely would not receive any overt acclaim or recognition, but that his force of unseen activism would make a far greater, more powerful change.

In other words, his prayers and mental intentions were actively working towards India's liberation, fueling the likes of Gandhi, who took the acting role in the physical world. She continued on, enticingly, that Aurobindo was incredibly pleased that his lifelong dream of India

being liberated from Britain happened on his **birthday**! OK - he was obviously a big fan of celebrating birthdays! Which brought me back to me - why was I here, so auspiciously, and so seemingly randomly?

At the edge of the register was a small booklet titled *Hymn to Durga*. I picked it up and began reading through it. I purchased the booklet from this thoughtful and well-informed attendant, thanking her for her information and time. I then sat outside in the courtyard to read it.

The booklet was a poem praising the Goddess Durga. It was incredibly lovely, and he used all my favorite words to describe Her, my beloved Goddess Durga: *Yoga Goddess. Mother of Victory. Rider on the Lion.* He continued on in poetic fashion, invoking Her to "manifest Herself in India." I closed the pamphlet, closed my eyes, and sat in meditation. I wanted to learn more.

Sri Aurobindo and The Mother

Sri Aurobindo was an Indian nationalist, scholar, poet, mystic, evolutionary philosopher, yogi and guru born in 1872 in Calcutta, India. After a short political career in which he became one of the leaders of the early movement for the freedom of India from British rule, Sri Aurobindo turned to the development and practice of a new spiritual path which he called "Integral Yoga," the aim of which was to further the evolution of life on earth by establishing a high level of spiritual consciousness (which he called the Supermind) that would represent a divine life. Sri Aurobindo wrote prolifically in English on his spiritual philosophy and practice, on social and political development, on Indian

culture including extensive commentaries and translations of ancient Indian scriptures, on literature and poetry including the writing of much spiritual poetry.

The Mother, who became Aurobindo's spiritual collaborator at his ashram, was the author of the pamphlet in my red purse, *The Mother*. She was born in Paris as Mirra Alfassa in 1878. She studied art, music and occult sciences in her early life, guided by spiritual experience at a very early age. In 1914, she met Sri Aurobindo in Pondicherry, India and in 1920 she moved permanently to Pondicherry to join him as his spiritual collaborator. In 1926, she was formally given full charge over the Sri Aurobindo Ashram and the spiritual and material welfare of the disciples who had formed around Sri Aurobindo by that time. She continued to expand the scope of the work of integration of the inner and outer life with the founding of the International Centre of Education, a model school which placed into practice the integral education methods developed by her. In 1968, the Mother founded the international city of Auroville (just outside Pondicherry) as a place for material and spiritual research for the future evolution of humanity to exist in harmony with itself and its earthly environment.

Aurobindo's library

Seeking more information, I went to Aurobindo's library, where all of his works are stored and available to the public for reading. When I arrived at the reception counter, I casually looked through a list of titles of Aurobindo's works, while skimming through random

selections. I came across a book listing of some of his personal spiritual poems, and was selfishly drawn to one title in particular. It was titled *Ahana*. The spelling looked similar enough to my own name, and with the kind of day that I was having, I was more than a little curious.

With some help from a library attendant, I found the book that contained this poem, *Ahana*. The poem was a call and response dialogue between *The People* and *The Goddess, Ahana*. The People were calling out to Ahana, crying for her to come manifest herself and to help them. She, Ahana, was quite resistant to their request. She did not want to come. She repeatedly told the people that they would reject her, use her, and betray her. She did not want to disturb her peace in the Heavens to manifest and experience such rejection and suffering.

The poem felt like a female version of the story of Jesus Christ. The Hebrews invoked him, but when manifest he was rejected, used and betrayed. Similarly, the Hindu people cry out for Mother Goddess to help them. I felt a strong empathy for Ahana, and I think that we can all relate to the fear of feeling rejection when we deeply love, ingratitude for sincere service, and disrespect for our thoughtful offerings. I cried while reading the rest of the poem because it really resonated with my own feelings in regards to the parasitic nature of our world. Aurobindo expressed these deep, disappointing feelings that I felt in such a precise and yet poetic way.

I have always felt different than other people. Since I was a child, my main focus was world peace, with a bleeding heart at the ways of our world. I never got caught up in worldly games or superficial attachments. I longed to live in a peaceful, loving world abundantly rich of nature. I mentioned earlier that growing up, my mother read esoteric

stories of the Virgin Mary apparitions and Nostradamus' predictions. My brother and I grew up calculating natural disasters, the end of the world, and if there was a way to alter that course of destruction. I simply didn't relate to Goldilocks.

Tony and Vijay

When I returned to my guest room later that day, I received a message from Vijay, the man who helped arrange my visit via email. The message indicated that he would like to meet with me, and requested that I call him. I returned his call immediately, and we arranged a meeting for the following morning. After hanging up the receiver, I walked outside to the edge of the ocean. There I sat on a rock and looked out as far as I could see. I was recalling the extraordinary events that had happened to me earlier in the day and trying to process them as the gifts that they were.

After about ten minutes had passed, I heard the sound of a motorcycle behind me. I turned around and saw a very attractive Indian boy on this motorcycle smiling at me. He said, "Hello," and I answered with the same. He asked me a few basic questions - where I was from, what was I doing in Pondicherry, and if I would like a ride on his motorcycle. His name was Anthony, and strangely enough one of the first things that he told me was that he was Catholic. I found this a little strange. An Indian Catholic named Tony?

Now, here lies my greatest struggle at that time, and a struggle that many women can relate to. I tended to fall prey to what a man wanted over my own desires, often overriding my personal spiritual

quests and self-realizing contemplation. Additionally, and however, with my travel golden rule, I couldn't help but to answer, "Sure." I hopped onto the back of Tony's motorcycle. He made a wide U-turn next to a large monument statue of Gandhi, heading back in towards the town center. We drove through town for several hours, and it was really wonderful seeing the night life of Pondicherry this way. Tony was very polite and kind.

The sun had long set and the smell of jasmines floated through the air. Tony pulled to the side of the road and parked his motorcycle, in an area of Pondicherry that I was not yet familiar with. He walked to a street merchant, buying a small bouquet of jasmine flowers that he gave to me when he returned. I had already stepped off his motorcycle. He placed one flowers in my hair and we began walking down the street together.

"I want to show you something," he said. There, in the middle of a predominantly Hindu town, was an architecturally impressive building that Tony said was his church. It was the Church of the Immaculate Conception, with a large statue of the Virgin Mary at its center. We walked through the beautiful church, while continuing to learning more about each other. Soon after this, however, I felt the pressure of having abandoned my own personal spiritual endeavors. I felt like I was getting sucked into a paradigm that I did not want to be part of. This led me to excuse myself back to the ashram. I thanked him immensely for the wonderful evening and ran back to my guest house. It was a spectacular birthday, even if I did cut it short.

The next morning, I went to visit Vijay, as we had planned. He was very well-spoken and he held his posture very properly. He had a

slim build, wore circular wire glasses, and was balding on the top, with gray and white hair on the sides and back of his head. Vijay was also the director of the school at the ashram, the International Centre of Education, founded by The Mother.

He began our meeting immediately asking me questions about my life. Yet, strangely, before I could answer anything he asked, he answered for me – and very accurately, at that. At first, I was taken back, side tilting my head and widening my eyes, wondering how he knew the things that he stated about my life, but soon it felt like the vastly powerful and unique gift that it was. He even knew about Rick, and what he called my "psychic love affair" with him. Vijay said, "What a grace that you have removed yourself from his spell." *How did he know these things? What was going on?!* The sound track of *The Twilight Zone* again played in my mind.

For the first time in my life, that I could recall, I watched my shoulders drop from my ears down to where they should naturally rest. For the first time in my life, I felt as though someone deeply understood me. The best part was that I did not have to struggle to find the words to invoke understanding or wrestle with trust and perspective to be understood. Words are often misunderstood, even minutely, and it is very rare to feel deeply seen and heard on such a profound level. This was truly divine.

He told me to pray to Sri Aurobindo and to The Mother and to ask them to guide me. I was so touched by his sincere gestures, and for his incredible help arranging my arrival. As a token of my gratitude I gave him two childrens books that I had written and illustrated (*A Chair*

in the Air and *Being Rosie*). He was very appreciative for the books. I likewise expressed my appreciation for his time and wisdom.

Auroville

When I returned back to my guesthouse, Anthony was waiting on his motorcycle out front. He asked if I wanted to go to the beach and to Auroville. Auroville, translated "the City of Dawn", and was developed by The Mother. It is "a universal town where men and women of all countries are able to live in peace and progressive harmony, above all creeds, all politics and all nationalities. The purpose of Auroville is to realize human unity." Naturally, I accepted his offer – remember, my only rule for this trip was to accept, and to go where I was advised to go.

After spending some time at the beach, swimming in waters that I later found out were highly contaminated and shark-infested, we rode to Auroville. Immediately upon arrival, I felt the joy and peace of this community. It was very much a happy, hippie, healthy town and I absolutely loved it. We ate lunch, shopped, sat in the grass, and talked about life. We absorbed the prospect of living in a world free of judgments and labels, and we compared the difficulties that limit the possibility of achieving this in India vs. America.

Soon, Tony began displaying romantic gestures, and I was again overcome with that aching feeling of having been too social and intimate. I felt the pressure to get back to solitary introspection where I could process my experiences, and it was time for me to go. Anthony appeared disappointed, and he was reluctant to end our lovely day, but

he was also kind and respectful enough to give me what I asked for. He drove me back to my guesthouse.

Navaratri

That night I walked into town, by myself, to watch the evening pujas at the Ganesha Temple. As I explained earlier, Navaratri is a festival celebrated all over India. The word *nava-ratri* itself translates as "nine nights." The symbolism of this festival explains that we are presently living in the night (in the darkness of ignorance). The Navaratri Puja signifies the removal of this internal darkness and the dawning of the light of knowledge. In this way, when the nine nights are finished, the tenth Day arrives: "Vijayadashami." Here, *vijaya* does not mean "victory" in the ordinary sense. Here, it signifies victory by breaking the shackles and the limitations of the mind to attain complete and total freedom. The word *navam* also means "new." When all the *papas* [negative tendencies] of the mind are washed away, we are born anew. We then understand that this body is the abode of the *Para-shakti* (the Supreme Power), and we experience the wonder and freshness of the Atma (Self) everywhere.

For the first three days of the *puja*, we worship Durga, whose mount is the lion. Durga is the embodiment of *shakti* (power). She is the fierce aspect of God. We worship Durga with the intention of removing attachment and aversion as well as anger and desire from within us. Only if we have *shakti* will our resolve be firm. Only then will we be able to destroy our internal enemies. Durga is the shakti that arises when the mind becomes still. The sword in the hand of Durga is the

symbol of *vairagya* [dispassion]. When I lead Yoga Teacher Trainings, I humorously joke at the irony of vairagya sounding like the antithetical Viagra. Vairagya is the sword of knowledge and the intense desire to know God. It is only with this sword and intent that we can destroy the dark qualities of the mind. This is the principle behind Devi killing Mahisha Asura [the Buffalo Demon]. Through the worship of Durga we are awakening the indwelling shakti. Only by awakening that shakti can we wage war against the weaknesses of the mind and emerge victorious.

After removing the negativities of the mind through the shakti of the Atma, the next step is to indoctrinate good qualities within. That is why we worship Lakshmi Devi, the embodiment of auspiciousness for the next three days. Through worshiping Lakshmi Devi, we should develop divine qualities such as love, compassion, kindness, charity, forgiveness and patience. When the negativities have been removed and the divine qualities have been seeded, then knowledge dawns. This, then, is why we worship Saraswati Devi, the embodiment of knowledge for the final three days of the puja. Durga clears through internal warfare, Lakshmi nurtures after the chaos, and Saraswati then teaches us rightful, victorious ways. The tenth day is Vijayadashami. It is also known as *dashara*. The meaning of this word is *dasha-papa-hara*: destruction of the ten papas [negative mental tendencies]. Vijayadashami is the day when one overcomes these ten papas and achieves the victory of Self-knowledge.

Phone Call from Vijay

The next morning around 8:00 AM, the phone in my room rang. I picked up the receiver. It was Vijay. He sounded very excited. "Alanna!" he said, "I love your childrens books! I would like to give your books to our childrens book publishing division to model as a format for their books. May I have your consent to do this?" I was both elated and flattered. I responded that I was honored, and that I consented permission, delightfully.

After we hung up the phone, however, I started to feel anxious again. I couldn't understand what was happening, and these divine experiences were happening faster than I could process them. The anxiety was in part from trying to control these very uncontrollable experiences. I still did not know why I was here, so coincidentally? Brushing aside my anxiety, I sought to learn more. I walked back into town, back to Aurobindo's ashram. There I sat at Sri Aurobindo's site and I prayed earnestly. I specifically asked him to help me publish my books. If Vijay found them so wonderful, I wanted to find a way to distribute them on a greater level. It was unlike me to pray specifically for an outcome, but this felt in line with Vijay's wonderful compliment to my literary works.

Even as I left the Ashram the anxiety continued brewing, and to a level that I was growing reactive. *It was time to leave Pondicherry*, I thought, even though I was tentatively scheduled to stay for a few days longer. In hindsight, I was feeling incredibly overwhelmed. Anthony had been calling my guesthouse quite a lot as well, wanting to go out. I didn't want to lead him on as it seemed that he had romantic intentions. I felt very bad for doing so, so I did not call him back. I was seeking a deeper connection within and a greater understanding to the events

that continued to unfold. I was not interested in a worldly romance on a superficial level.

I walked towards the Ganesha Temple. There, outside the Temple, I met a girl from Costa Rica. We started talking about our trips and where we had been. Our organic connection immediately calmed me down. There was no language struggle or profound meaning to digest; simply two wanderlust girls sharing our travels. She asked me where I was traveling to next and I told her that I didn't know. She pulled out a flyer advertising an Ashram that she had just returned from. She told me that I should go there. The bottom of the flyer read: *Friday nights: Sri Chakra Puja*. I smiled while confirming in my mind that today was Thursday. Instantly I knew that I must go there. She told me to keep the flyer, and we said goodbye. It resonated deeply that this was right. I decided that I would leave Pondicherry the next morning.

Leaving Pondicherry

The next morning, after I finished packing my belongings, I brought my duffle bag downstairs, setting it on a chair in the lobby next to the reception desk while I gathered my documents for checkout. My bag was unzipped. On the very top of my things was a copy of my childrens book titled, *Searching For Light*. I proceeded to the reception desk to check out. While I was working out my payment and paperwork with the receptionist, I saw a man looking at my bag in the lobby. I excused myself from the receptionist and walked into the lobby to ask the man why he was looking at my bag. "Is this the Aurobindo calendar?" he asked me. I looked confused. I replied, "No. That's a

childrens book that I wrote." He replied, "Oh. Wow. Did you know that the alternate website for Sri Aurobindo Society is *searchforlight.org*?"

That strong feeling of anxiety found its way back into my chest. Of course, there is an alternate website to Sri Aurobindo Society that has the same title as a childrens book that I wrote. Of course. I removed the book from my bag and walked back to the reception desk. I asked the lovely receptionist if she would watch my bag while I went to visit Vijay. She agreed and I placed it behind her desk. I walked out the door and sprinted to Vijay's office while clutching *Searching For Light* in my hand.

Vijay's office

I walked into Vijay's office. He was eating lunch. As he looked up at me I held up the book, saying, "searchforlight.org?" He said, "Alanna, come. We must talk." I followed him into the living room where we sat across from each other on separate couches. The furniture appeared handcrafted, with rich fabrics and colors. The room felt cool,

possibly from the large metal statues placed throughout it, and the fact that it was set away from any sunshine.

Vijay asked me, "Alanna, who does the publishing for your books?" I answered, "I self-publish, Vijay." He asked, "Well, who does your distribution?" I answered laughingly, "It's a one-woman show over here. I do that as well." He then spoke magical words that massaged my ear drums as the sound passed through my ears, "Alanna, when you get back home to the States, I want you to mail me all of your books. Then let's talk about Sri Aurobindo Society publishing all of them for you."

I was speechless and beaming with elation. Thank you, Sri Aurobindo! I had literally prayed to him, less than five hours earlier, for help finding a publisher. That was fast! I ran back to the guesthouse, bursting with joy and excitement. I retrieved my bag from the receptionist, thanked her and proceeded outside where I grabbed a rickshaw taxi ride to the bus station.

Arriving at Maharshi's Ashram

I sat at the very front of the bus, in the single seat next to the driver. He was a very funny Indian man. We connected instantly. He would point out things of interest to me, like monkeys, children playing, political signs, buildings, or beautiful scenes of nature. We traveled through countless small towns that each looked the same as the next. Everyone dressed the same, all of the shops and product offerings were the same, the colors were the same, and the people all looked similar. It cost me less than five dollars to travel half way across the

country of India on this bus, partly because it took around six hours total, but I greatly enjoyed the slow, countryside drive. I arrived in Tiruvanamalai in the early evening.

Once arriving at the Tiruvanamalai bus station, I immediately took a rickshaw to the Ashram of Ramana Maharshi. It is a very large ashram at the base of a large hill. I quickly found the director of the ashram. I asked if there was room for me to stay at the Ashram that night. He informed me that there was not, that the accommodations were full. He recommended a place called Arunachala Inn, across the street and down a short road. I thanked him and walked in the direction he instructed.

The streets were very noisy and dirty, and there was far more action happening here than in Pondicherry. When I arrived at Arunachala Inn, my first impression was that it did not appear to be the cleanest place to stay. I was hesitant to enter to seek room, but I proceeded regardless. Standing outside, next to the entry steps was an older woman. She was dressed in orange robes. I was initially taken

back by how much she looked like my grandmother Mary, my father's mother. I asked her if this was a nice place to stay in the area. She looked at me, but did not respond. Irritated by her seeming rudeness and lack of response, I proceeded to enter and find the manager. I asked him if I could check in for the night and possibly a few days.

The Inn was very close to the main street near the ashram, which made it very noisy. I looked inside the room that was available. Yes, it was also very dirty. Knowing that I had little options, and that this was the suggested hotel from the ashram director, I disregarded my aversions and agreed to stay for a few nights. After paying the manager, I set my bags inside my new room. I was admittedly uncomfortable about this, but considering that I was arriving late and knew absolutely nothing about where I was, I was in no position to complain. Within minutes I walked back to the ashram, as it was Friday and the Sri Chakra Puja was to be that night!

Sri Chakra Puja

A Sri Chakra Puja is a temple ritual devoted to the unconditional love of the Divine Mother. I had packed with me (of the few items I mentioned already) a Sri Chakra Puja, and had hoped very much that I would be able to attend a ceremony. When I saw the notice on the bottom of the ashram advertisement, my anxiety was transformed into great excitement.

When I walked into the temple, the ceremony had already started. There were about seventy-five people sitting in rows down the middle of the temple. There is a pathway in most temples that leads you to the sacred tabernacle area. This pathway is where the people were sitting. Everyone was chanting while a man, assumed to be a priest,

assisted by two young boys, performed the puja rituals. He burned incense and circled it around a bronze image of the Divine Mother. I was standing off to the side of the temple, observing from a distance, as I did not want to disturb the ceremony, especially since I had arrived late.

An Indian woman wearing glasses stood up from the floor and approached me. She hugged me, took my hand in hers, and guided me back to the floor where she was sitting. I did not resist, and I sat down next to her, happily. She continued to hug me, then she swayed and rocked me, all the while smiling ecstatically. I began to cry, actually, from the immense amount of kindness and love that this woman was showing me, a woman whom I had never even met before.

After about fifteen minutes, everyone stood to his or her feet. This woman, still holding me, also helped me to stand up. We danced. We laughed. We smiled with our hearts and eyes. We continued dancing through the temple tabernacle area, with the entire group, stopping as she put sandalwood paste on my forehead. In all of the confusion, excitement and people, I lost her in the back of the temple. I

looked all around. I wanted to thank her for her unbelievable outpouring of love and thoughtful ceremonial inclusion. That experience would not have been as profound, nor would I have participated so joyously had she not made the effort to include me.

Feeling incredibly light and deeply full of love, I walked, no I floated back to Arunachala Inn. I did not sleep one wink at all that night, for several reasons. I was basking in the surreal buzz of divine love running through every cell in my body, for one thing. Secondly, I was afraid of being eaten by a rat. I laid on my bed (covered with towels, of course) and laughed at the dualistic emotions running through me. That was surely one beautiful way to experience a Sri Chakra Puja!

Arunachala

When the sun rose the next morning, and the hustle and bustle could be heard on the streets below, I walked into town. I needed to go to the bank to withdraw more cash. As I was returning back towards the ashram, a rickshaw stopped in front of me on the street. An

American man poked his head out of the rickshaw. He asked me if I would like a ride. I agreed, thankfully, and got into the rickshaw, knowing it was heading towards the ashram.

We started talking a bit about where we were from and what not. He was from San Francisco, and his name was Joel. When we arrived at the ashram he asked me if I would like to join him for a Chai tea at the café across the street. I agreed, and we walked across the street, sipped our tea, and talked more. I asked him about the Hill, and the sacred symbolism of it. He told me that the Hill is the actual effulgence of Shiva, the Hindu god. Similarly, as Catholics believe that the Holy Eucharist is actually the body and blood of Jesus Christ, Hindus believe that this Hill is actually the only physical manifestation of Shiva on the planet. Obviously, it is very sacred.

We then began discussing our personal philosophies. Joel admittedly had quite an obsession with gurus. I laughed that I was the opposite. I typically do not follow gurus, or view them as anything more than a great teacher, and I believe that we all have our own guru within to awaken and listen to. After another thirty minutes of discussion Joel said, "You know, I've learned more from you in twenty minutes than I have learned from my all gurus in twenty years. Do you mind if I spend the day with you?" I felt a little uncomfortable with his highly complementary statement, but replied, "I don't mind at all, as long as you promise not to place me on any pedestal. I'm afraid of heights." I laughed. "I'd like to climb the Hill today," I continued.

We gathered our belongings and headed across the street, passing through the ashram to the base of the Hill, Arunachala. We started walking up through the plush natural landscape. We walked for

at least twenty minutes, casually talking and learning more about each other's lives and philosophies.

When we hit a longer stretch, part of a steep hill, we saw a very skinny, old Indian man with a long white beard dressed in orange robes descending towards us. He was carrying a walking stick, and when we approached him, he stopped. The man looked at me, turned slightly to his left while pulling up the side of his robe, revealing a deep puncture wound on his lower leg.

Well, if you hadn't already figured by my towel laden bed covers and anti-parasitic tinctures (and have I mentioned that I haven't eaten any food here in India, so as to avoid getting a parasite?), my purse was a medicine cabinet. I asked the man to sit down on a nearby rock. I pulled out the hydrogen peroxide in my bag, then the tea tree oil, and then some aloe. I applied each of these onto his wound in that order. I then wrapped his wound with a plastic bag that I had in my purse, tying it around his calf. All the while that I was doing this he was

repeating the same word over and over while holding his hands in prayer position in front of his chest. I did not recognize what he was saying, and I was too focused on my medicine woman skills to inquire.

Joel asked me, "Do you know what he is calling you?" I replied, "No." Joel said, "He is calling you Shakti; Divine Mother." I laughed, thinking of myself dressed in a surf shirt, straw sun hat and flip-flops as the Divine Mother, but I appreciated the lovely gesture and I smiled to the old man. I wore two brass bracelets with the Sanskrit mantra "Om Namah Shiva" inscribed on them. After I finished wrapping the old man's leg, I took one of the bracelets off and gave it to him as a gift. He was delighted. I can see his beaming, smiling face in my mind right now as I type. He thanked me deeply, and we continued on in our opposite ways.

As I continued hiking with Joel I asked him what the word "Arunachala" meant. He replied, "It means *the House of Aruna*. Aruna is

translated as the "blazing redness of the Sun." It is the name that Shiva gave to Durga (Arunadevi) after killing the demon Mahisha. Durga

resides as the feminine aspect of Arunachala. She is Shiva's consort and this hill is her house. In the ancient texts it states, Shiva said: "This Durga, the destroyer of Mahisha, the deity born of your part, shall be present here itself, yielding the Siddhi of Mantras to men . . . Here in the sacred place of Aruna I shall also remain by the name of Aruna. You shall also be here by the name of Arunadevi. Since Aruna and the Lord are always present here, all the siddhis will be easily accessible in this holy spot of Aruna to those who entertain a desire for them."

I honestly wasn't expecting more Goddess symbolism here, let alone to Durga. Jesus. I saw a chilling similarity in relation to Durga, and the names that she has been given. As we continued walking, we arrived at Skanda Ashrama. This cave (as well other spots close by) is where Ramana Maharshi sat for fifty years to reach Samadhi, or Blissful Realization. During this time, he became so still and clear that he actually saw the Spirit world. He saw the deities conversing and fighting, creating and destroying. Joel told me that he wanted to go

inside the sacred cave to meditate. I, being a higher, more agitated energy (especially after what he had just told me), decided to continue walking on, for now. We parted ways, expressing our hope to catch up with each other later on.

Vipassana

Joel referred to *sitting* with the Hill. I also heard other people using this verb: "The Hill will speak to you if you *sit* with it," they said. As I have already explained in greater detail, I have sat extensive meditations in the Vipassana technique. Just as this implies, the verb used for the Vipassana practice is *to sit*. I found this interestingly familiar, although the very strong message was obviously not sinking in yet, as I chose not to meditate at Skanda Ashrama. As I also mentioned earlier, I discovered Vipassana in a very interesting way. It was the great gift from my friend, Scott Fallows. My anxiety at that time, however, was still overriding my ability to sit still.

Climbing to the top of Arunachala

As I continued walking along the path, I came across a vivacious young Indian boy who jumped in front of me while proclaiming, "There's a man meditating on the top of the Hill! Fifty days he's meditating! Want to see?! Want to see?!" I was delighted by the young boy's energy. I told him that I would love to go with him to see the man meditating.

Now, remember, I was only wearing flip-flops, so climbing this hill with large rounded rocks was quite challenging at times, as was following this exuberant boy who was climbing very fast. At one point, we had to cross a long, open-faced rock that was very slippery. I walked slowly, with both hands and feet (monkey-style), and as I looked across this long rock I saw a man squatting on the very edge of it. He was looking out over the city of Tiravanamalai. He was wearing orange robes, draping his robe around his shins as he hugged them tightly towards his chest.

My first impression was that he did not appear happy. He glared at me, actually. I smiled. He continued staring at me, so I smiled once more, and even waved hoping my kind greeting would invoke the same in return. Then he smiled. This felt like a mini victory, and I continued along. I remember his face very clearly as it was a piercing moment, difficult to forget.

Soon the boy and I made it to the top, and to the cave of his destination. Inside this small cave was the skinniest and happiest man that I had ever seen. He was absolutely radiant! We spoke through the language of laughter, as neither of us spoke the other's language, and honestly this is my language of preference, anyway.

I removed my digital camera from my bag, and started taking pictures of him, and of us. I showed him the instant images and we continued to roar with laughter. I figured by now that this was a posed scenario to invoke a monetary tip from a visitor on Arunachala, but regardless I deeply enjoyed it and I played along.

We laughed, and laughed, and laughed. This lasted for about twenty minutes, and I even took my very first "selfie" (see photo). The young boy then guided me back down the Hill, once again passing the intense man squatting on the edge of the rock, overlooking the town. When we returned to the spot where I had met the boy, I took off the other "Om Nama Shiva"

bracelet that I wore around my wrist. I gave the bracelet to the boy, along with some money. I told him that he was a servant to Shiva on this sacred Hill and that he should wear the bracelet as a reminder of that. He was very happy and skipped away.

My Shiva Lingam

After I watched the young boy skipping away I noticed a man to my right, sitting on a blanket selling stone carvings. He was also carving the stones into the images of Hindu deities. There were also carving replicas of the Hill, which I later learned were called Shiva Lingams. He asked me if I wanted to buy something, and I replied that I did not. Two minutes later, as I began walking away from him, down the path on the Hill, I started to slip on a rock. As I slipped, almost in slow motion, I tried to do it as gracefully as possible. I braced myself with my right hand on a rock behind me as my left big toenail caught underneath the rock in front of me. I watched my nail lift right off my skin, and instantly my toe began to bleed.

The man selling stone carvings immediately ran over to me. He demonstrated strangely grand energy, bowing and pressing his palms in prayer toward me. While doing this, he called to his friend, who also came running in my direction. When he saw my foot he also reacted equally strange by bowing with his hands in prayer. I re-assured them both that I was fine, and not to worry. I knew the drill and I was fully prepared. I pulled out my hydrogen peroxide and started to clean my wound.

The figurine merchant ran back to his station, only to return to me immediately after. He was holding a Shiva Lingam, a stone carving of the Arunachala Hill. I thought this was a very odd time to close a sale, and I told him once more that I did not want to buy anything. He then insisted on giving me the Lingam stone image of Arunachala. He said, "You must have! You must have!" Tired of the hustle about this, I accepted the stone carving graciously while still holding a napkin around my left big toe. Giving in, I thanked him while reaching into my

purse for some money to pay for the stone. He quickly said, "No! This is gift. No pay!"

That was the first time that I had seen an Indian street merchant turn down money, which made this gift extra meaningful to me. I thought that maybe he felt sorry for me having hurt myself, and I sincerely thanked him once again. After I finished cleaning my toe wound, and it was bandaged securely with a rubber band to hold the napkin tightly in place, the man's friend invited me to see a "private temple." Naturally, I agreed. I walked with them off the path where we came to a small stone temple dedicated to Sai Baba. There were roughly fifty pictures and deities in this small stone temple, and the men quickly pointed out a picture in the center.

"This is our guru, Sai Baba. He is meditating on the Hill right now, fasting and praying for thirty days." I looked closely at the picture. I recognized him as the man I had seen earlier on the edge of the rock. I told them that I had just seen him. I added that he seemed a little grumpy up there. They didn't get my humor, and I may have responded a little too blasé about having seen their special saint, but they could not believe that I actually saw their guru. "What?! You saw Sai Baba?!" the friend asked, as the stone carver exclaimed, "One look into his eyes and all of your karma will be removed!" he continued. *Interesting*, I thought. I clearly did not act impressed or ask any further questions about him. I merely added a few rupees into the donation pot and said my goodbyes. I continued walking back towards the path.

Holy Tirtha

Back on the main path, I walked for another ten minutes or so before turning off of the path on a smaller trail. There, in private, I could use "nature's restroom." As I finished pulling up my pants, I stepped back onto the smaller path to proceed back to the main one. At the same time, four young Americans walked by; two boys and two girls. They all appeared to be in their late teens. We exchanged a friendly greeting to each other. When we realized that we were all American we stopped to talk at greater length.

I asked them where they were going. One of the boys replied, "We are going swimming. Would you like to join us?" Naturally, I said, "Yes," although there comes a point in continual acquiescence where your own personal desires, limitations, and fears grow increasingly challenged. At this point, I started feeling a backlash of discomfort that arose as anxiety. I tried pushing through it and continue my commitment. It obviously hadn't proven wrong in the least bit, as my unplanned trip was turning out to be quite extraordinary. It was just happening too fast.

I understood this to be part of my ego surrendering to "what is" and not "what I want." During this kind of training, our desires often want to be heard, much like a child desiring a cookie even when they are told that they cannot have one. With time, we develop addictions to our desires, and the backlash becomes greater at those stages. I wasn't anywhere close to those degrees of control and/or attachment, but I was aware of feeling uncomfortable.

I walked with my new teenaged friends for about twenty minutes, off of the main path. I had no idea whatsoever where we were, nor did I have a map of any kind. They shared that they were students

enrolled in an international engineering study program at an Indian university for three months.

When we arrived at the swimming hole that the teenagers were seeking, it appeared more like a stagnant pool of water. Now, having clearly displayed my hyper-hygienic nature and fear of parasites, you would never think that I would dip my body in these stagnant waters, would you? Let alone with an open wound on my foot?!

Yet, I do not exaggerate when I tell you about this example of angel hacking. I felt as though I was possessed. Something beyond me was taking off my clothes. Internally my mind was viciously fighting me with fearful and vastly intelligent thoughts of the health risks of doing such an act. Regardless of these thoughts, I removed my clothes and stepped my naked body into the water.

Once in the water, I acted in a relaxed manner even though my mind was in a fit. As I was talking to my new friends, I reached into my bag, pulling out my new Siva Lingam to show them. Within seconds after this, I somehow regained total control of my senses. I instantly acted upon my previously suppressed fearful thoughts and jumped out of the water faster than a frog hopping from a boiling pot.

I quickly dressed and said a hurried goodbye while running off. I was incredibly disturbed by what I had done. They must have thought I was mad, frankly. I walked quickly, and then I ran down the path. It started to rain, and I sloshed through the mud. Then came the thunder and lightning. I could only envision getting back to my hotel room, retrieving my bags, and getting on the first bus out of town. I didn't care if I was planning to stay another three days. I wanted to get out of this place and find a clean, hot shower, now!

I continued running in the rain, slipping several times in the mud, which only dramatized my sense of contamination and lack of control. While running I decided that I would purchase a book at the ashram bookstore explaining Arunachala. I was absolutely content to learn about this place while sitting on a bus, exiting town. I had had enough! When I finally reached the bottom of the Hill, I turned down the ashram path, which I could see in the distance. When I reached the ashram, I headed straight towards the bookstore.

On my way, I ran under an awning to get out of the rain for a moment and gather myself. There was another woman under the awning. As I turned to her, I instantly recognized her. It was "Mama"! The woman who bathed me with unconditional love at the Sri Chakra Puja the night before. My mood quickly shifted out of its fury. I pulled the hood back from over my eyes and lovingly said, "Thank you!"

As soon as she recognized me, she lit up with joy and hugged me. I was starting to feel better again. I then began telling her how grateful that I was for her love and guidance during the puja, but she motioned with her hand to her mouth that she was in silence. I ceased my intense outpouring of gratitude, feeling discouraged that I was

unable to communicate with her. I motioned a warm *thank you* with my hands in prayer and touched my heart to respect her silence. With my head heavy, I continued along to the bookstore.

Upon entering the bookstore, the first book I saw on an endcap facing the entrance was titled, *The Glory of Arunachala*. I really had no desire to shop around or ask questions. The book had an illustration of Durga and Shiva merged together on the cover. *Perfect*, I thought, *this was the book that I would get*. Done. I took it to the counter, paid for it, and left. I probably spent no more than four minutes in the store. I was still very intent on a quick departure from town.

Rosalind

When I hit the noisy street from the ashram, I turned to my left, toward my hotel. As I glanced down the street ahead of me, I saw the woman who was outside the Arunachala Inn the night before – the one who wouldn't answer me. "Grandma" was about fifty yards ahead. She was walking in the same direction I was, toward town. I didn't pay it much attention, put my head back down, and continued to walk. Before I knew it, Grandma was standing right in front of me, perfectly still, looking out to the fields across the street.

I stopped in my tracks when I saw her. I was about to detour around her when she asked me, "Do you still need a place to stay?" I replied reactively and sarcastically, "Noooo, thank you. I am heading out of town as I speak," and continued around her. She said, "Please, be patient with me. My feet hurt. Come with me," while motioning for me

to follow her, heading in the opposite direction that we were both previously walking.

I felt my resistance wanting to walk away and get out of there, but something settled. Her energy was soft but commanding. It reminded me of my acceptance vow. I agreed, although quite lackluster. We walked along the busy road for another twenty minutes, which added to my irritation, honestly. My mind and heart were both racing, and I felt my jaw clenching. She was completely unfazed by my huffing and puffing.

She then guided us over to the farm roads, which were set behind the main roadway. There, the noise diminished and with that, I started to calm down. I watched my physical tension subsiding, and my body exhale. I asked Grandma what her name was. After a sideways glance of hesitation, she replied "Rosalind." I then asked her where she was from. After another longer period of hesitation, she replied, "Spain...but I don't speak much," with an implication for me to stop asking questions.

Well, it seems that no one wants to talk to me around here, I thought to myself. Mama is in silence, and now Grandma doesn't speak much. I was tired, and I acquiesced as I continued walking with Rosalind in silence. I had no idea where we were going.

Soon we arrived at a smaller, quaint ashram. There was a large gate with a sign on the outside that read *Nannagaru Ashram*. As we walked inside the gate, an Indian man walked into the courtyard to greet us. He bowed to Rosalind, calling her "Mamaji." *Mamaji?!* I thought, while looking at her from a different perspective. She replied very simply to the man, "Raju, would you please give this young

woman a place to stay for four nights?" I quickly rebutted, "Sorry, but I told you that I am leaving today." She repeated her request to Raju with the exact wording without looking at me or acknowledging what I had just said. Raju replied, "Yes, Mamaji. I will prepare a room for her now." *Hellloooo??* I thought in my mind. *I'm right here! I just said I am leaving town!*

Well, as I looked around the peaceful ashram, set away from all of the noise, I did feel more comfortable. There was a beautiful flower garden - and best of all, it was quiet. Mamaji left as Raju took me into the ashram to see my room. It was spacious and clean. I was finally content. I thanked Raju and told him that I would retrieve my belongings from Arunachala Inn and return back shortly. He was an exceptionally kind man, adding the offer to use one of his bicycles to get around town during my stay.

I was starting to comprehend the consistent overt signs telling me to *be quiet*, and *to sit*, but it had not yet permeated my dense, action-addict being. I still had to *do* something. As I finished my conversation with Raju, I walked through the courtyard toward the gate. I exited to

my right, as that was the direction that I had arrived with Rosalind. There wasn't much around this rural ashram, mostly distant homes and farms. The dirt road that I turned onto was fairly wide and the sun was setting on the horizon, creating a beautiful dusk scenery. Just as I stepped onto the road, a motorcycle pulled up in front on me, seemingly out of nowhere. There was a man and woman sitting on the bike. They came to a complete stop right in front of me, without acknowledging me in any way. The female passenger was seated behind the male driver and she was holding an infant in her front papoose.

The man's head was turned away from me so I could only see the back of his head, but strangely enough, there was a strong sense of familiarity that I felt. I was riveted on this man, which made me stop walking and only stare at him. They seemed to be calculating their direction and still showed no awareness of me in the least. Yet, after about another minute, the man turned his head in my direction. I was still standing there, staring at him. The events that were happening in the last week were overwhelming, but what happened next was the final straw to discipline my wild spirit.

After staring at each other for about a minute in absolute shock, I finally choked up one single word. "Scott?" I asked. The man seemed equally surprised, and responded, "Alanna?" It felt as though someone released the final bit of air from my balloon. I felt too overwhelmed to react; I had nothing left. For the first time, maybe ever, I was truly speechless. In hindsight, I suppose that was the intent. It was Scott Fallows, the man who introduced me to Vipassana meditation back in Los Angeles. He, like Joel, was from San Francisco, the heart chakra of

Kali-fornia. I humbly and simply said, "Fancy meeting you here." I certainly couldn't react. I felt broken, strangely, and I could only witness what was happening. My throat sank into my heart.

As I tried catching my breath, Scott told me that he was on a vacation with his wife and newborn child. He said that they were staying in northern India, but had spontaneously decided that morning to take a motorcycle ride to southern India. I was still having a hard time grasping what was happening. A spontaneous motorcycle excursion, where he would appear in front of me on a rural Indian dirt road while the universe was trying to tell me to *sit*, in the same fashion as the meditation technique he introduced me to half way around the world years earlier?

I gulped my words and sank deeply into the moment. Nothing that I could say or do would supersede this awesomeness. I didn't want to do anything that could alter the beautiful perfection of dharma happening before me, but honestly, it was a lot for my human mind and heart to process. Unable to be more social, I simply excused myself after congratulating him and his wife on their new baby. I told him how great it was to see him. I now understood the messages very deeply. The universe is telling me to *shut up and sit down!* No one wanted to talk to me, and Scott was the greatest symbol of silence that I knew. He symbolized Vipassana.

"Sit with the Hill." This is what Joel and several other people were saying about Arunachala. "It will speak to you," they said. My energy shifted dramatically. It was time; time to sit. I had been racing through my trip, just as I raced through my life. I quietly, still in shock, walked into town to retrieve my bag from Arunachala Inn. I stopped by

Maharshi's ashram before returning to Nannagaru. There, I partook in the evening meditation and Navaratri celebration. I felt myself settling, unwinding, grounding, surrendering, and finally able to *sit*.

Nannagaru Ashram

After the evening's festivities at Maharshi's ashram, I returned to my new temporary home at Nannagaru. As I walked through the courtyard, a woman stepped out of her room, which was on the first floor, directly below my room. She caught my attention as she waved to me, smiling with excitement and joy. I then realized that it was Mama! Silent, Loving Mama was staying here too! I waved back and continued walking, knowing that I couldn't speak to her, and also void of my own desire to do so.

Raju was standing by the stairwell. He greeted me with a loving smile and asked how my evening was. I told him about what had happened since I last saw him, but nothing of great detail, because I just didn't have the energy to speak much after seeing Scott. I was still in shock. I did tell him about Silent Mama, though, and my first night in Arunachala at the Sri Chakra Puja. Raju looked at me intensely. I was confused by his shift of personality. He told me that Silent Mama had a major tragedy in her life fifteen years earlier. He said that she stays at his ashram every year during the anniversary of the tragedy, to mourn in silence.

He told me that a car had fatally struck and killed her daughter while she was walking on the road. He continued, "She would have been your age." As he said these words we both looked at each other

with similar intensity, in silence, knowing that this answered the mystery around her behaviors towards me. It was clear that we both understood my energetic relationship with Silent Mama. I was entering the Sri Chakra Puja to receive Divine Mother healing. She sought to express her motherly love for her lost daughter. I symbolized her daughter during the Puja celebration, and she became my surrogate mother, so to speak. Tears welled up in my eyes and I excused myself to my room.

The Glory of Arunachala

After I entered my room, I laid on the bed to rest. I pulled out my new book *The Glory of Arunachala*, and began to read. The book was written by Ramana Maharshi, the saint whose ashram sits at the base of Arunachala and where I have been attending services for the last few days and nights. I had never heard of him before Thursday (three days prior).

As I mentioned earlier, Ramana Maharshi sat on this very Hill, Arunachala, meditating for fifty years. In the introduction of his book, he explained that he became so still that he witnessed the spirit world occurring. He saw Durga kill Mahisha, and many other divine stories of Hindu mythology. He witnessed dialogue between the deities, and this book was his re-telling of what he saw.

Maharshi starts the book by describing the origin of Arunachala and the power of the Hill. As I also mentioned earlier, it is believed by the Hindus to be the only effulgence of Shiva. He then went on to explain the multiple ways in which one may receive graces from Shiva

on this sacred Hill of Arunachala. Although my monkey-mind skipped ahead to later chapters, enjoying the play-by-play interaction of my favorite deities with more specific detail than I had ever heard before, I was very interested to learn more about Arunachala, so I focused on reading this section as to how the Hill blesses those who walk on it.

The first way to receive grace, the book stated, is *1) to help someone in need on the Hill.* I thought, *Hey! I helped the old man who had cut his leg!* I was super excited to have read this, and filled with pride while remembering how I helped the beautiful old man as he passed by Joel and I on our climb up the Hill that morning.

The second way to receive grace on Arunachala, the book continued, is *2) if your foot sheds blood while walking on my holy Hill.* I rested the open book on my chest, face down. *Hold up.* I was starting to feel overwhelmed again. As you know, while I was descending the Hill that morning, my toenail lifted as I slipped on a rock. It definitely shed blood. I moved the book next to me on the bed. I sat up alert, hugging my knees into my chest, staring at the blank wall. I stayed there, motionless, for at least thirty minutes. That all too familiar *Twilight Zone* feeling was back once again.

After that bout of shocked stillness, when I felt that I could breathe again, I picked up the book once more. I had a small sliver of capacity to read more, mixed with deep curiosity. I began reading where I left off. The third way to receive grace from Shiva is by *3) holding a Shiva lingam in your hand,* ... wait for it ... *while bathing in my holy waters on Arunachala.* I was now zapped; fully maxed out with capacity. I threw the book to the end of the bed, staring at the ceiling

with wide eyes, breathing heavily. This was really tripping me out. That outlined several major, unique events of my morning on Arunachala.

I couldn't read anymore that night, and I tried to get some rest. I didn't sleep deeply, in the least. I was hyper aware of everything happening around me. It felt more like a state of deep meditation mixed with perplexing fear and a heaping dose of poetic synchronicity on the side.

When the sun rose the next morning, I went out on to the open rooftop with my yoga mat. I had a gorgeous, direct view of Arunachala. This was probably one of the most divine asana practices that I have ever had in my life, and I finished the first series of Ashtanga Yoga before meditating with the Hill for just under an hour. I felt a deep sense of bliss, which gave me the courage to continue receiving my journey.

When I returned to my room, I picked up the book again. I took a deep breath, and I continued reading where I had left off the night before. The next action listed in the book, as to how one receives grace from Shiva was to circumambulate the Hill, or circle the base of Arunachala, which was 14 miles around. I decided that this is what I would do today. I was relieved that this was fairly straightforward and void of information that could potentially stir more anxiety. I was in the perfect state to continue exploring Arunachala without being mentally distracted. I packed my purse, borrowed Raju's bike (which was inscribed with the name Margo), and I rode into town.

Circumambulating the Hill with Laxshmi

Every morning while in Arunachala, I bought a coconut from a woman named Laxshmi. She sat across from the ashram with a cart of coconuts, selling individual coconuts that she cracked opened as a beverage for her customers. The rupee cost of one coconut was equivalent to twenty cents in American currency. Given this low price, I gave Laxshmi the equivalent of two dollars. As you can imagine, I quickly became Laxshmi's VIP customer. She would have a line of ten or more customers, but when she saw me coming, I received the next coconut. She always demonstrated selecting the very best one for me.

On this morning, as usual, I arrived to purchase my coconut from Laxshmi. While she was cutting it open, she asked what my plans were for that day. I told her that I was going to circumambulate the Hill. Without a moment's hesitation, she replied, "I'll take you." She didn't even wait for me to respond as she called her husband to approach. She

told him to work the coconut cart. That was it. I now had a companion to circumambulate Arunachala.

After I finished my coconut water, we began our walk. I wore flip-flops, and she was bare-footed. In hindsight, I cannot imagine not having had Laxshmi take me around the Hill. She knew many of the special places to visit, and I most certainly would have been lost without her. She led me through small villages, to significant temples, and pointed out places of great interest that would easily have been overlooked.

We walked arm in arm, sweat on sweat, for the entire day, and it was an absolute delight. During the last mile of our walk, I was filled with so much gratitude that I wanted to buy her a cart for her coconuts, so that she did not have to sit on the ground. Gosh, I wanted to buy her a house! We returned back to Maharshi's ashram just as the sun was beginning to set. I gave her a generous monetary tip, and we hugged. She didn't speak much English, and I most certainly did not speak her language, but we shared a deeply profound day together regardless.

After our walk, I crossed the street to visit Maharshi's ashram. There I sat in the evening meditation, and enjoyed the Navaratri festivities. Afterwards, I rode Margo back to Nannagaru to rest for the night. When I returned to my room, I felt at peace enough to continue reading *The Glory of Arunachala,* where I had left off that morning.

I washed my face, hands, and feet and relaxed on my bed. As I turned to the next section, the book began delving into Maharshi's re-telling of Hindu mythology – the play of the gods and goddesses – again, as he saw it. The myth of Durga and Mahisha came to life with dialogue and action. This was especially satiating to me in the same way as watching a good movie. I was enjoying it so much that my only fear was that the book was finite in pages. I didn't want it to end.

Maharishi described Parvati as the pure form of Goddess. Her consort was Shiva, and together they created and destroyed the world. According to Maharshi, Shiva stated:

"The Goddess represents this divine illusion as Maya. It is through Her that the universe appears and disappears. Creation, sustenance and destruction take place through Her. I display out of my freewill, this wonderful world which is like a picture..."

He also describes their union as such as he speaks to the Goddess:

"I am the ocean, you are the Ganga; I am Ego, you are the Buddhi (Intellect); I am the wind, you are Sama (Stillness); I am the sea, you are the wave; You are Knowledge, I am the object of Knowledge; you are the word, I am its meaning. It is by our command that the acts of creation, sustenance and destruction are carried on. You and I are inseparable. You separated yourself of your own accord, took on a form and underwent severe penance. I shall reward you for your love for me. Henceforth you shall be part of me and shall become the left half of my person."

The Goddess has many manifestations, or personalities. Durga was the warrior manifestation that killed the arrogant and abusive demon, Mahisha. Upon completion of her task, she gave thanks, cleansed, and returned back to the form of pure Goddess, Parvati. Then, the book continued, to give thanks to Shiva, she:

"... circumambulated the Hill ... with Laxshmi ..."

Again, I threw the book down onto the bed, placed my hands over my head while watching my chest rise and fall to match the intensity of my breath. I have never re-gained the courage to continue reading the rest of the book. To this day I still have not finished it, for several reasons. Yes, it frightens me a little, but I am also frightened

even more to think that this extraordinary magic is finite. The book sits on my bookshelf, and I love knowing that there is more waiting for me, if I choose to pick it up.

Leela

I decided to go out to dinner that night. I had finally stirred up a real hunger that justified a meal (instead of a Greens Plus bar and a scoop of royal jelly honey). I dined at a welcoming restaurant, owned by a couple from England. The owner's three-year-old daughter was joyously dancing around the restaurant, and this made me feel very happy and comfortable. Her name was Leela. I asked what her name

meant, but she did not know how to answer me. Her father answered me, instead. He said that her name meant *The Play*. Leela means *play*; the play of life; the opportunity to see our interactions with the eyes of an open heart rather than with our physical eyes; to distinguish what is real from what is illusory; to intentionally engage in life, knowing that it is a dramatic production.

I enjoyed a delightful evening. Nothing happened that was too overwhelming for my mind to become anxious, even though there was enough beautiful synchronicity for my heart to keep smiling. I spent the next three days at Nannagaru Ashram, quietly practicing yoga and meditating on the rooftop while overlooking Arunachala. I was finally able to *sit still*.

Mysore

When it was time to leave my little heaven at Arunachala, I took another bus across India, heading to Mysore. Again, I sat in the very front single seat of the bus. There aren't many traffic regulations in

India so the driving can be a bit alarming and chaotic, to say the least. I preferred sitting in front so that I could see what was happening. The back of the buses often become overcrowded.

I arrived in Mysore in the evening. The Mysore Palace was lit during this festive Navaratri season, and it was quite a majestic arrival. From the Mysore bus station, I took a rickshaw to the Ayurvedic center

where I was registered to stay. I would be partaking in a nine-day Panchakarma cleansing program.

When I arrived at the Indus Valley Ayurvedic Center, or IVAC, an incredibly pleasant and charming woman named Vinita greeted me. Vinita was expecting me. As she gave me a tour of the grounds, she informed me that the guest numbers were abnormally low, and therefore I was upgraded to a superior room, complimentary. This was a wonderful and welcomed treat, especially given the lack of luxury my previous accommodations had offered. The facilities were built on a coconut grove at the base of Chamundi Hill. That name should sound familiar to you – it is, according to mythology, where Durga killed Mahisha after their long, nationwide battle. Vinita then escorted me to my room while explaining the protocol and agenda for the upcoming nine days of treatments. I unpacked, got settled, took a long, blissfully hot shower, and went to sleep.

There was another woman staying down the hall from me. She was from Mexico City, and her name was Berta. Other than Berta there was another couple staying at IVAC, but I had not yet seen or met them.

I was told that they were upgraded to the presidential Suite, similarly to how I was upgraded to the superior accommodation.

According to the Ayurveda tradition, a doctor oversees your Ayurvedic treatments, especially if you are doing a more intensive program, such as a Panchakarma, as I was. The next morning, I met with my doctor. He was a very jolly man, and very, very funny. He took my physical stats during our exam. We talked about what kinds of food that I would be taking, and what kind of treatments that he recommended for my dosha.

In Ayurveda, a dosha is one of the three vital bioenergies (Vata, Pitta, and Kapha) condensed from the five elements (fire, water, earth, air, and ether). The attributes of the doshas and their specific combination within each individual help determine the individual's physical and mental characteristics, while imbalance among the doshas is believed to be the cause of disease. My dosha was Vata-Pitta. I had a strong air-fire quality to me. At that time, I had extremely little Kapha, which explains why I was, metaphorically, a walking spark. Even my astrological chart is composed mostly of air and fire (Libra Sun, Sagittarius Moon, and Leo Rising). I only have one planet in a water sign and one planet in an earth sign.

Each day I was scheduled for an Abyanga Sweda, which is a flowing oil massage followed by a steam bath. The therapists prayed over me prior to my treatment, and they helped me bathe afterwards. The therapists treated me like royalty, and it is a very surreal and sacred experience. In addition to a daily massage, I also received a daily basti, or enema, which included a mixture of powerfully cleansing herbs. The

same therapists arrived at my room to administer the enema concoction. They then left me to relax with the herbs brewing in my lower bowel. This was the basis of treatments that I would be doing for the next nine consecutive days.

Ashtanga Yoga Institute

The next morning at 5 AM, I took a rickshaw to the Ashtanga Yoga Research Institute in Mysore. Pattabhi Jois, or Guruji, originated this style of yoga, and this was the style of yoga that I practiced. In many ways to an Ashtanga yoga practioner, Mysore was our Mecca. When I arrived at the Institute at 5:30 AM, I waited in the lobby area to be called into the practice room when space became available. Each student had an assigned arrival time in order to stagger space as efficiently as possible. The practice was not *led*, it was *Mysore style*, which meant that each student performed their poses at their own pace, on their own.

Guruji's grandson, Sharath (whom I had met before in the US), called me into the room. I placed my mat in the area he indicated and began my practice. Surprisingly, with a room full of practitioners he was very attentive and helpful throughout my practice. When I had finished, however, the office was closed to officially register, so I made plans to return the same afternoon.

Once back at IVAC, I enjoyed my morning treatments. I couldn't hold the enema concoction for more than two minutes, however, even though they recommended forty-five minutes. The door barely closed after the therapist left, and I was running to the toilet. I was feeling exceptionally amazing, though, and I enjoyed a deep nap after lunch.

Upon waking from my nap, the IVAC driver took me back to the Ashtanga Yoga Institute, so that I could officially register with Guruji. Guruji was in his late eighties, and he had a smile that could warm through a snowflake. He carried a large, overweight belly, wore four gold chains, and a large gold watch. When I entered his office, he was counting stacks of rupees on his desk, appearing more like an accountant than a yoga guru, until he looked up, that is. It was then that his soul radiated to touch mine.

Guruji told me that he only takes students that come for a minimum of three months, but since I study with one of his favorite students in the US (Tim Miller - who is one of the first American students to study with Guruji), that he would let me practice with him each morning by rotation, as well as privately with his daughter Saraswati each afternoon. I agreed, and we began immediately. Saraswati lived across the street from the shala.

Saraswati is the name of the Hindu Goddess of knowledge, and that day was the first of the final three days of Navaratri dedicated to Saraswati. The symbolism of her name was not overlooked. To the contrary, it was greatly appreciated given my Navaratri journey. I arranged my yoga sessions with both Guruji and Saraswati each day.

That evening, after practicing with Saraswati, I took a rickshaw back to IVAC. Mid-way through the ride I noticed a large, twin-towered cathedral. I asked the driver to take me to it. It was a Catholic church. Its patron was St. Philomena. That rang a bell of familiarity. As I mentioned earlier, I *accidentally* brought a novena to St. Philomena with me on the trip after picking up my mail the day I left for the airport. My mother had sent it to me. A novena is a nine-day prayer, and I knew nothing about Philomena prior to these instances.

I spent some time in the church, received a tour of the catacombs underground the church, and I stayed to offer prayers. I also decided that I would come to the church every morning for mass to pray my

nine-day novena prayer to St. Philomena before going to practice yoga with Saraswati, in conjunction with my nine-day Panchakarma cleanse, and with the nine-day Navaratri Festival to the Goddess. The fact that the nine days didn't coincide did not dilute the power of each nine-day celebration. It was all very magical, especially given that nothing had been planned ahead of time.

Chamundi Hill

The next morning, I went to mass at St. Philomena's church, practiced yoga with Guruji, and returned to IVAC for my daily treatments of oil massage and basti. In the afternoon, I sat down with the Doctor. He taught me how to read a pulse, and other valuable healing techniques, according to ancient Ayurveda principles. Somehow - I wish I could remember specifically why - we both ended up laughing until we cried laughing. I really enjoyed his personality.

In the evening, my driver drove me to the top of Chamundi Hill. In response to the prayer by the Gods and Goddesses to save them from the demon Mahisha, the Goddess Durga killed this monster on top of Chamundi Hill in the town of Mysore, India. The scripts read that after killing the monster, Durga stayed on top of the hill, where she is worshipped with great devotion to this day. It was profound for me to be experiencing the actual locations where this myth took place.

There were hundreds of people waiting in long lines to get into the Chamundi Temple for the evening's Puja. Apparently, that evening symbolized the transformation of Chamundi into Durga, the Maha Maya, or Supreme Illusion. To symbolize the transformation, incense

would be burned in the temple from 4:35 am-4:36 pm the next day. I waited in the long line and I followed the rituals. I offered my flowers and monetary donation. Then, shortly afterwards, I felt a very sudden and deep chill. I also felt faint. Because this came on so suddenly, I decided to leave early. I hired a rickshaw driver to take me back to the Center. Once there, I went directly to bed.

Around 4:30 AM, I awoke, soaked in my own sweat. As soon as I became conscious, I could feel that I was burning up with a raging fever. My mouth was dry, my head was pounding. I felt disoriented and uncomfortable. I had the most extreme fever that I have ever experienced in my life. I called to the front desk and asked for water to be sent to my room, in hopes of cooling myself down. I told the receptionist of my fever, but he expressed that he did not know what to do. Oddly enough, given how accommodating the IVAC staff had been to date, the water was never sent to my room. I stayed in bed, drenched in sweat-soaked bed sheets, barely able to open my mouth from dehydration, bating hopefully for a water delivery that would never arrive. I then fell back asleep.

Festival Procession at the Mysore Palace

I slept in the next morning, which was the grandest day of the entire Navaratri, the Day of Victory! Ironically, today was also my father's birthday back in Buffalo, NY. Although I still wasn't feeling well, I forced myself to go to the Procession at the Mysore Palace. I couldn't bear the thought of missing the Day of Victory Procession. I

was still very feverish, achy, and slow moving, but I pulled myself together as best that I could.

When I approached the Palace, I saw thousands of people lining up to enter the gates. This large mob of people greatly discouraged me,

and I turned around. I decided immediately to go back to IVAC and rest. A man working at the admissions turnstile must have witnessed my change of mind. As a result, he ran to me saying, "Come, Madame. Come with me. No wait in line. No pay. Just come." I accepted and turned back toward the Palace with him.

He escorted me into the Palace and placed me in a section designated for Press, which had seating. I was greatly relieved to not be standing in the public crowds during the Procession, especially since I was still feeling weak. I had a free, front-row seat for the Parade! I thanked him greatly, and took a seat while watching people prepare for the Procession.

The Procession was absolutely phenomenal. The costumes, the animals, and countless groups, beautifully choreographed offering their thanksgiving and celebration through dance, art, and acrobatics.

Apparently, these groups arrived from all over India to contribute to this spectacular show. Everyone danced and performed with such devotion that I cried throughout most of it, feeling their heart-felt expression.

When the Procession ended, I walked back to the street, looking for a rickshaw to return to IVAC. It was about 4:00 PM. I saw a woman selling fresh coconuts on the side of the street. I purchased a coconut from her, and drank the water. Instantly, and I mean instantly, I felt better - much, much better. I didn't seem to have a fever anymore, and my body aches vanished.

Meeting Rohm

At IVAC that evening, the doctor invited me to a pre-dinner performance of a nationally celebrated vina performer. A vina is a stringed instrument of India that has a long, fretted fingerboard with resonating gourds at each end – almost like a guitar-shaped cello that is played like a guitar. The performance was held in IVAC's yoga room,

and there were only four guests in attendance, including myself, which was all of us currently staying at the center. It was an inspiring, relaxing, and lovely performance. Afterwards we all headed to the dining room for dinner.

In the dining room, as I walked by the only male guest, whom I had not yet met, my periphery took note of the logo on his t-shirt. Quickly, it commanded all of my attention. I was so shocked that I even read it out loud, as if in slow motion, "Santa. Monica. Prana. Yoga?!!" *What?! That was Rick's yoga studio!* I slowly looked up at the man and noticed that he greatly resembled Rick, except older. My mouth fell open, while the man held out his hand with great confidence. He said, "Rohm. Rohm Kenter; very nice to meet you." *Oh my God, it was Rick's father!* I politely shook his hand and barely uttered my name and the phrase, "I know your son," before running to my room in total disarray. Needless to say, I skipped dinner that night.

*This could **not** be happening! No! Edit! This is **not** part of my spiritual journey.* I started to cry. I was angry. *I did not come half way across the world to heal at this Center to be with Rick's father! No! And on the Day of Victory and my father's birthday, no less!* I struggled to understand any symbolism, synchronicity, or logic because I was blinded by my emotions. I went to sleep with a very agitated state of mind.

The Doctor's Concern

The next morning the doctor came to my room, very concerned about my health, and the fact that I had skipped dinner the night before. He said that he had heard about my fever, and was concerned about me

continuing my treatments. Feeling a great comfort level with him, I immediately told him that not only was I feeling better, but also about my situation with Rick's father. I explained to him how I had become obsessed with his son, and the psychic struggle that had ensued between us. I told him that a major reason that I was here, traveling half way across the globe was to heal from that very relationship, and that I have unknowingly come across his father, on the Day of Victory!

The doctor bowed to me while placing his hands together in front of his chest. He said, "Alanna, you are very blessed. God is blessing you. Whatever you wish, whatever you want to do, you tell me, and we will prepare it for you." He told me that my fever not only expressed my anger, but also coincided with the Navaratri festivities. He told me that Hindu's specifically celebrate Durga's transformation from Chamundi from 4:00 AM (the time that my fever started) until 4:00 PM (the time that my fever subsided). As he described this to me, I related to his imagery. Had I become human incense – burning out my anger, cleansing, purifying, and praying? I hugged him and I thanked him. I told him that I would continue my treatments as we had originally planned, to which he agreed.

My time with Rohm

The next morning, Rohm's wife, Marion, fell ill. Berta did as well, ironically. Both of them were taken into town to go to the hospital for medical treatments. It was now only Rohm and I continuing our Panchakarma, and interacting at mealtimes on fifty acres of coconut groves at the base of Chamundi Hill. We were the only visible guests at

the Center for the next few days. I tried to resume my vow of acceptance and receptivity, which my initial meeting with Rohm had deviated from.

I didn't have the strength to tell him about his son, Rick. Moreover, my stomach would literally go into knotted spasms when I started to. I mentioned nothing about the struggles that we had, or even how well that I knew his son. Rohm was one of the first forty or so yoga practitioners in the 1970's to practice Ashtanga yoga on the island of Maui. He studied with the first American students to have visited Mysore and practice with Guruji in 1972. He was a very wise, kind, and deeply intuitive man. Ironically, I learned so much about Rick, as well as gaining sincere compassion for Rick, by listening to Rohm's stories and witnessing what a wonderful man that he was.

He seemed to see right into the essence of who I was, in a similar way that Vijay did, back in Pondicherry. He was highly intuitive, and highly complementary. He told me many things that I have never shared with anyone else since. "Nobody sees you, do they, Alanna? You walk into a room, and you heal everyone there, and nobody has any idea that it was you, if they are even aware that it happened at all." That felt a little too grandiose for me to embrace, but the idea of feeling unseen definitely strummed the feelings in my heart, just as it did reading Aurobindo's poem, *Ahana*.

I was very frank with him, as we welcomed a deeper level of honest and intimate conversation. We spoke about the struggle with desire and lust, and his words have stayed with me ever since. He said, "Alanna, if anyone should lust and judge, it should be you because deep down inside your intention is purer than anyone I've ever met."

Rohm was the first to hear about some of the wonderfully synchronistic tales occurring on the first part of my trip in India, and how they related to other major events in my life. He took note of one particular pattern that I had never noticed before. He said, "Your life seems to run in two year cycles." After thinking about it, I thought, *Yes, I can see that as true.* Rohm continued, "Alanna, you will return here in two years. And I want you to visit me in Venezuela afterwards." We made a date to meet again in two years' time. He gave me a shell figurine of a woman meditating as a reminder. That figurine has been sitting on my altar every day since I returned home from India.

Meaning

There are many strong and recurring themes in my life: Goddess, Mother, Durga, Victory, Buffalo, Father, Love, Warrior, Maha, Dancer. There is a kaleidoscope of light, shadow, ego, soul, deity, archetype, fighter, dancer, lover, destroyer, truth, and karma swirling around.

Growing up, my parents had a very passionate, but dysfunctional relationship. Neither had good communication skills, and

loud screaming wars, fighting, and grown-up tantrums were the norm. My father was a Vietnam Veteran with severe PTSD that he refused to get treatment for. We grew up walking on eggshells, as my father's anger was ferocious. I, however, was fearless towards my father from a very young age. Even though I was younger and a girl, I was often the one to defend my brother in both playground scuffles or at home when my father's wrath emerged.

I didn't run away like others did. I glared right back fiercely, gripping a wooden plank or leather belt meant to be used for a whooping. I refused to accept the dysfunction and grew up as a voice demanding change and consciousness. Strangely and understandably, I was the only one to see the deeply wounded heart within my father. I was the only one to stand in the rain, or outside the family van when he locked himself inside during stubborn acts to push everyone around him away. I persevered and disregarded the abuse for the pain I felt, sensing his inner suffering. Most nights, I woke up at 2 AM to offer my father a homemade lunch, and/or to tell him that I loved him as he walked out the door to go to work. He never accepted my lunch, and he growled back disapprovingly at my expressions of love, but it never deterred me from doing the same thing the next night.

My father always had a moustache, which wasn't very common until recently in our millennial *Movember / Age of the Lumberjack* fashion statement that started around 2012. When I was a child, I had a horrible, recurring nightmare for at least eight years. The nightmare was that a man had broken into our home while my father was away at work. I heard the break-in and saw a shadowed figure down the hallway as I raced into my mother's room to protect her.

I knew where my father kept his gun, and I opened his dresser to get it. Holding the gun, locked and loaded, I waited for the shadowed figure to move closer. When he did, the moonlight illuminated some features, but not nearly enough to make out who the man was. The light revealed a moustache. That's where the panic and night sweating began. I couldn't shoot, ever. I froze in the sheer panic that it could possibly be my father. I later connected the irony that one of the only other men in our small town who had a moustache was Charlie Mixon, Sr., who murdered Linda and her children. When I arrived in India, I was struck with how many men wore moustaches there. The images of Durga fighting Mahisha were illustrated with Mahisha (and his army) with moustaches. With my mother being the textbook Leo, I started to see my personal family dynamic in the myth associated with the personal patterns and archetypes recurring in my life.

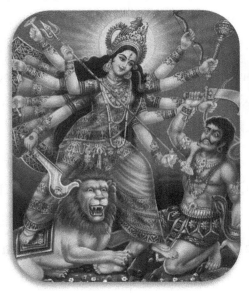

Even the fact that Mahisha was a *Buffalo* demon and that is the very city where I was born and raised. Now, my father was intense,

stubborn, and difficult, for sure. However, he was no demon. He worked hard to provide for us, protect us, and held deep love for us, buried beneath his wounded heart. He is truly the most accurately and astutely aware human being I have ever met. Quick-witted and aware to a shocking level that nothing passes his perception. His assessments of people have rarely been wrong, even if it took years for them be realized. I inherited this same "gift," which can feel a lot like a curse at times, especially in a world padded with delusion and addiction-numbed egos controlling our culture, politics, and legislation. I see straight through people and their ploys to feed their hungers and addictions, which I refuse to partake in. In addition, I am fearless to stand up for what is right.

The experiences I had as a child certainly bred me for who I have become, naturally. Over the past thirty years, I watched my mother not only gradually change her behaviors and reactions in a more positive manner, but as a result, literally heal my father. She became a prayer warrior and her prayerful passion slowly healed our family. I was the voice of consciousness while she fueled the energy of deep, passionate, divine, and unconditional love.

I am very proud of my parents and their journey together. They are beautiful, talented, and passionate. I am happy they have each other, through good times and bad, and that is the greatest victory. Although being raised in such chaos took a great toll on me, it required deep self-work and transformation to find my way through. The obstacles that I have overcome have forged the depth of power, love, and wisdom that I offer as a teacher and activist for peace.

Conclusion

"Synchronicity is an ever-present reality for those who have eyes to see." -Carl Jung

The stories I have shared with you in Volume 1 are only a select few of the countless stories of synchronicity my life has graced me with. These stories begin at a young age, and as I progress further with newer stories in Volume 2 and 3, the themes mature along with me. I continue to thread together powerful, universal themes and profound discoveries that I hope will help you unshackle and release any delusions, fears, and/or unnecessary ego that you may be bound to, as a means to live the authentically graceful life waiting for you. Quite simply, as the great Carl Jung said, "The privilege of a lifetime is to become who you really are."

Breaking linear beliefs is mind expanding and overwhelming. It is much more difficult to flow through the beautiful kaleidoscope of life

when we are clinging to attachments along the way, or afraid to look at shapes and colors that are different than the ones we associate with and are accustomed to. The synchronistic universe does not have a beginning or an end, nor does a wave. The motion is not up and down, forward moving only. It is cyclical, multi-dimensional, and multi-directional. We are participating in its creation only in the present moment of Now, as a sort of time-traveling art show, as a means to both focus and surrender to the journey. Who could express this any greater than the White Queen to Alice in *Through the Looking-Glass* by Lewis Carroll, "It's a poor sort of memory that only works backwards." We do remember the future; it's called intuition.

My entire life I have been judged for being incredibly free-spirited, innovative, ahead of my time, spontaneous, spiritual and a seer of synchronicity. Those who are afraid, jealous, and/or limited by worldly perspectives may likely try to discourage and diminish your experiences as "hocus pocus," "coincidence," and "fantasies," as they have tried to do with mine. They have every right to believe what they believe, but I hope you never let the dust blind you from your own sunshine. If they can't hear the music, you'll understand why they can't dance. Spirits do not belong in a cage, not even self-made cages with the doors opened wide.

I've been a bit of a female Forrest Gump throughout my life, in that I am far less focused or involved in worldly matters than most people I know, or the "who's who" of celebrity culture. Even without a worldly plan, my life has been profound, innovative, and epic. I have traveled with rock stars, politicians, authors, gurus, Hollywood executives, and world-famous designers. I have maintained a positively

influential position to influence those who influence the world. I haven't owned a television for twenty-one years. Living in a celebrity-centric city, I stumble upon celebrities frequently. I often interact with them without knowing who they are. I stay connected to my inner GPS and consciously work to not allow culture to sway my positions or destinations.

In 1997, I began leading Goddess Retreats. No one was using the term *Goddess* during that time, and I received eye roll after eye roll because I did. When the Grand Ole Internet first came out, and we had our pick of domain names, I was struggling with several to choose from. During a phone call with my brother, while driving to a spa one afternoon, I told him that I was going to buy *www.zgoddess.com* as my website, to list my classes and retreats. He bawked at me saying, "When are you going to get over that Goddess shit, Alanna?!" I was dismayed with his response, and continued brainstorming for something better. While in the sauna, I pondered the notion of *www.alannazabel.com* but that felt too boring, too straightforward. Then *www.alannaiam.com*. Nah, sounded weird. Within twenty minutes into my sauna, I concluded *www.aziam.com* or *Alanna Zabel I AM*.

Now, today, I watch the flashy *Goddess* culture on social media and with reality show stars that I see in the news. The obsession with plastic surgery, fake followers, fake news, and Photoshopped images. Now, I am the one trying my best not to roll my eyes. Yet, I know it is part of the greater universal Leela. The ripples farther from the point of impact will not vibrate as true as the ripples closest to the impact will. We're still expressing the Goddess revelation upon us, regardless. I am grateful that I was unraveling my shackles and leaping to break my

own glass ceiling during a time when it was not en vogue, oversaturated, or part of social media culture. I mean, we only had pagers back then. Regardless, it just feels good to be a woman right now, and everyone is feeling the Girl Power vibe. We will express it or react to it in different ways, however, according to our personal paradigms.

I have kept these sacred stories as my personal hidden treasures, because why would God grace a shy girl from a blue-collared family who cares less about the vanities of the world than she does about world peace, a grand title such as *Goddess*? Age and wisdom have now taught me otherwise. A Goddess is not an over-sexualized image, or a person dressing to look like a glorified image of a queen. In fact, it is the opposite. She is one who denounces these things or hierarchies of status, who stands up for equality, peace, and nature. She chooses the planet's environmental health over a pair of toxic breast implants. She refuses to play dysfunctional male/female roles, seducing or gratifying sexuality for reward. She is far from prude, but her value is not defined by her sexuality. I will illustrate far greater details of these concepts in Volume 2 and 3 (hint-hint), as you follow me to Copenhagen, Austria, Thailand, and back to LaLa Land.

As I mentioned earlier, I teach teachers. This means that I have structured programs and manuals to train people as a means to deepen their understanding of yoga, its history, and the responsibilities of becoming a teacher. I have never heard anyone address the gross deviance of our culture's belief and practice of the sacred, spiritual Tantra philosophy.

Buddhist and Hindu Tantrism emerged during the Tantric Age, roughly 500 – 1300 AD. In Hinduism, the Tantra tradition is most often associated with its Goddess tradition, called *Shaktism*. Tantra teachings championed enlightenment through the exhalation of the body's energetic potential. After the largely cerebral interpretation of the Yoga Sutras, this approach was a reaction to the dualistic and a prescribed asceticism prevalent at the time.

Tantra reinstates the value of Goddess worship, and is characterized by inclusion of the Divine Feminine principle in the form of Shakti. Tantra has been commonly but incorrectly associated primarily with sex, given 1) the associated worldly perceptions of women (valued as sex objects) with worship of a Divine Feminine, and 2) it contrasted the repugnance of intimacy in colonial prudish Victorian values (during the time when these teachings gained popularity). It tainted the Divine Feminine reverence with a limited perspective of women during that time, which has perpetuated, and become justified with the practices and beliefs of those limited times. We, as women, have evolved far too far to return to limited paradigms of being valued solely for our sexuality and ability to bear children.

I know that we're evolving as humans. We're re-realizing who we are, and who we came from (remember, memories work equally in the past and future). We're dancing the Leela, and playing with both our light and shadows, co-creating this unique and profound experience of artful existence.

Thank you for walking through memories, experiences, and realizations of my deeply personal journey with me. Although I am open about my personal love for travel and deeply honest self-

exploration, I whole-heartedly agree with Mark Twain, leaving you with his warning that **"Travel is fatal to narrow-mindedness, prejudice and bigotry."** Be prepared only to be free, as you are.

CPSIA information can be obtained
at www.ICGtesting.com
Printed in the USA
FSHW021322111220
76611FS